PAINTING
FOR THE

Soul

Quarto is the authority on a wide range of topics.
Quarto educates, entertains, and enriches the lives of our readers—
enthusiasts and lovers of hands-on living.
www.quartoknows.com

The original German edition was published as *Malen für mich*.

Copyright © 2015 frechverlag GmbH, Stuttgart, Germany (www.frech.de)

This edition is published by arrangement with Claudia Böhme Rights & Literary Agency,
Hannover, Germany (www.agency-boehme.com).

Photos: frech publishers GmbH, 70449 Stuttgart; lichtpunkt,
Michael Ruder, Stuttgart; Isabelle Zacher-Finet (Schrittfotos)

Concept and Production Management: Hannelore Irmer-Romeo

Editorial Office: Melanie Schölzke, Stuttgart

Translation from German: Merry Foxworth

6 Orchard Road, Suite 100
Lake Forest, CA 92630
quartoknows.com
Visit our blogs at quartoknows.com

Printed in China
1 3 5 7 9 10 8 6 4 2

Painting
FOR THE
Soul

Soothe your soul,
expand your imagination,
and paint your way to colorful,
creative expression

ISABELLE ZACHER-FINET

Table of Contents

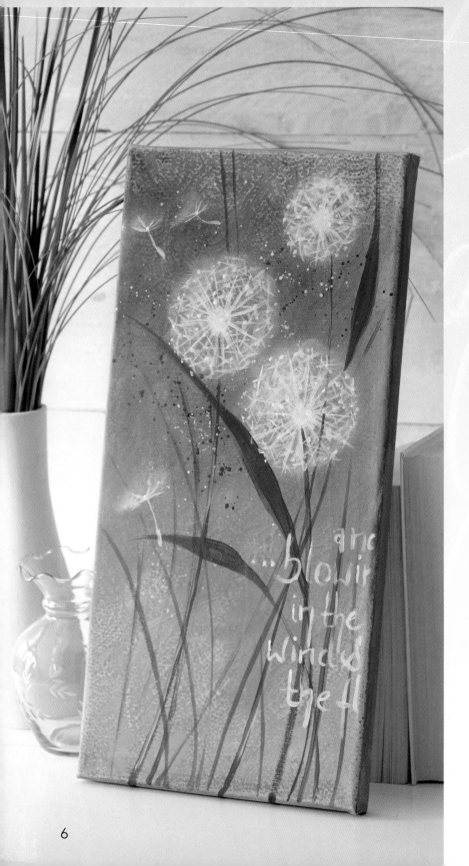

Introduction

In an ideal world, there would always be time to make art. Most of the time, however, life and daily routines and responsibilities get in the way. And even when we do find the time to be creative, we often are haunted by thoughts like, "I should be doing…" or "I need to do…" followed by whatever obligation is at the forefront of our minds.

Painting for the Soul is designed to help you find time for creativity in your busy life, as well as assist you in forging a path for your personal creativity to flourish. You'll discover how to:

• Create beautiful and inspirational art.

• Paint for your own personal enjoyment.

• Set your worries aside to enjoy some well-deserved creative time.

This book is both a creative guide and an inspirational support to help you get started in your artistic journey without being too specific about what you "should" do; therefore, this book is not simply a collection of projects with point-by-point, step-by-step instructions. Instead, you will discover the joys of painting your everyday realities through the context and feelings of your soul.

How to Use this Book

Rather than "musts" or "shoulds," this book offers suggested materials, instructional guidance, and tips to give you enough information for you to start painting in your own personally expressive way. Also included are ideas for practicing variations to the art methods described.

The goal is for you to enjoy total creative freedom in making your artwork. Although I share my thoughts and inspiration for creating my art, I encourage you to develop your own style. Soon you'll see your own personal works emerge from your soul.

With best wishes for your creative journey!

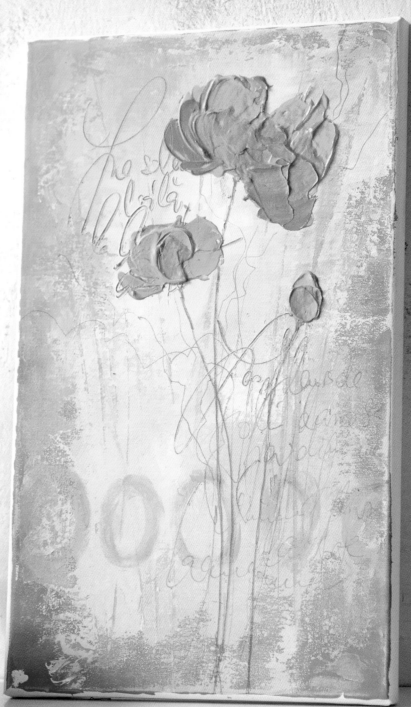

Making Space for Creativity

Painting is my passion, but it is also my occupation. For me to be successful, I must sometimes plan ahead and schedule time to paint. My studio is a pleasant, vibrant space. But because it is also my "office," I need to remind myself when I am painting for work and when I am painting just for my soul. You do not need a large home studio in order to paint for yourself. On the contrary, painting for the soul should take place in your own personal creative sanctuary, whatever that is for you. I paint in a small sunroom while sitting on a bench at a small table. Three drawers allow me to store my materials of which there are few: a small selection of brushes; some canvases, pens and markers; and about 30 or so paints.

Setting the Tone

I find that a few small rituals help set the tone for my soulful painting sessions. For example, I enjoy having a cup of coffee with my art journal by my side and my favorite music playing in my headphones. A childhood quirk means I quite like sitting on window benches and in doorframes, which help me feel serene and peaceful, similar to how I imagine my cat feels when she is sleeping snugly in a box. With beautiful music playing and while seated in a comfortable position, I am free to empty my thoughts and ideas into my art journal or onto my canvas. I treasure this time alone with my favorite things. Alone, in well-worn jeans and a comfy top, I feel at ease. I am ready to make art!

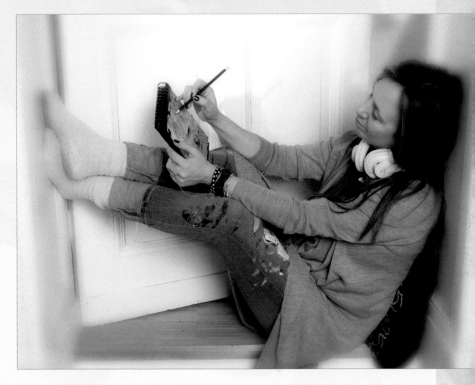

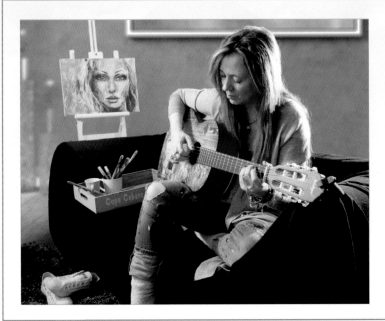

Ending your Creative Session

End your creative session much in the same way that you begin it—with a ritual. I treat myself to a favorite beverage, stand back, and admire my new art. Sometimes I play my guitar, since music and "my time for the soul" are inseparably bound to each other. These are the things I love most: my art and my instrument. This is my unique ritual—something very much my own. At the close of my creative time, I am able to return to my everyday existence feeling refreshed and recuperated.

Tools & Materials

Creative time-outs should not have to begin with expensive shopping sprees and long lists of supplies. Look how much you can do with just a few drawing and painting tools!

Acrylic Paints and Mediums

I primarily use acrylic paint and acrylic mediums to create my artwork. Acrylic is easy to use. Paints can be diluted with water and all of the implements can be easily cleaned with water, as long as the paint has not already dried. Acrylic dries to a waterproof state. Some artists believe that because acrylic dries quickly, it can hasten—and therefore disrupt—the creative process. This is only true under certain conditions. The drying time of the paint is influenced, for example, by the thickness of the layers. Thicker layers not only require more time to dry, but they also allow more time to repaint. I have tried to limit my use of colors in every featured project; therefore, I often use white to create different color mixtures. But don't limit yourself to the colors I have chosen! If the urge moves you, use as many colors as you desire. After all, this is *your* creative time!

▶ Acrylic mediums include such items as pastes and gels, which are designed to add structure, thicken, or change the consistency of the paint.

A gel is usually colorless and dries to a milky or transparent appearance. Gel medium does not change the shade of the color but instead influences the paint's consistency and top layer according to the binder-to-pigment ratio of the mixture. A structural paste can be either white or colored, which makes it suitable for direct paint mixtures that will alter a color's shade. Some brands of acrylic paint already have a pasty consistency, making a structural medium unnecessary.

Brushes

Brush sizes can vary from manufacturer to manufacturer. I prefer a range of sizes from small to large; however, don't get hung up if you don't have the size of brush that you think you need. If I do not have a larger brush available, I can simply adjust my strokes with a smaller brush to achieve the same effect. If I have a large brush but not a smaller one, I will use its point, corner, or side instead of the entire width. The same goes for the type of brush hair. If, for example, I do not have a soft synthetic bristle brush that I think is ideal for my project, I can certainly use a bristle brush successfully. This usually makes a bolder stroke, which results in a different appearance, but that doesn't mean it's wrong! Each type of brush can be employed in many different ways, making it possible for a small assortment of brushes to be quite adequate for a variety of projects. Experiment with various types of brushes to see which you prefer.

Soft-haired synthetic brushes are generally more suitable to the even application of paint.

Brush Recommendations

I recommend the following for to start your initial collection of brushes.

Three synthetic flat brushes:
1 small ($1/8$ to $1/2$ inch)
1 medium ($1/2$ to $3/4$ inch)
1 large (1 to 2 inch)

Two synthetic round brushes:
1 small (size 2 to 6)
1 large (size 10 to 14)

Two flat bristle brushes:
1 small ($1/8$ to $1/2$ inch)
1 large (1 to 2 inch)

Other:
An old frayed painting brush that can be used for backgrounds.

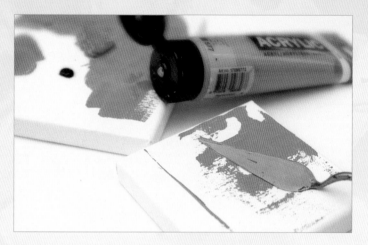

Palette Knife

A metal palette knife is preferable to a plastic palette knife, which generally has less tension and a flimsier edge, resulting in less specific strokes. A palette knife offers many varied possibilities for use, depending on whether one uses its surface, side, edge, or tip. Palette knives come in a variety of shapes and sizes. Deciding which type to use is often up to one's personal preference. To start, I recommend two tapered knives with longer edges, one small and one large.

An old plastic credit card can sometimes make up for the unavailability of a palette knife. You can even create entire pictures with them! (Curiously, plastic cards have more tension and offer more possibilities than plastic palette knives!) Experiment using a plastic card as your primary tool to see what kind of results you can achieve.

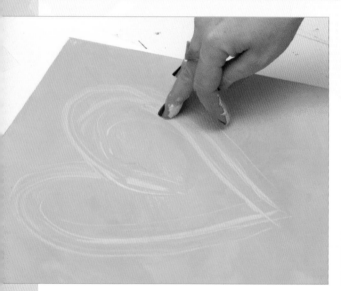

Hands and Fingers

If you're open to experimenting, you'd be surprised at what lovely artwork can be created using your hands and fingers. (If you don't want to get your hands messy, try wearing latex gloves.)

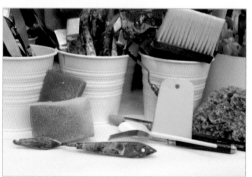

You can also substitute any number of common household objects for a painting brush or other tool, including sponges, spatulas, cardboard, a plastic spoon—the possibilities are endless!

Drawing Implements

Pencils, colored pencils, and markers are all useful in contributing certain effects to your artwork. Pay attention to the type and size of marks your implements make to ensure they meet your expectations. Also, make sure they dry to a waterproof finish on a smooth underlying surface, which makes them suitable for use on canvas.

Palette or Paper?

To get the most out of every tube of paint, do not use a paint palette, which will have to be washed off, thereby losing valuable color. Instead, use Kraft paper, printer paper, newspaper, or another kind of paper to hold your paint. When finished, allow your paper "palette" to dry and set aside. Soon you will have a great selection of collage paper that can be incorporated into mixed media projects later on. Alternatively, you might choose to create small hanging art objects or use these papers as gift wrap.

Paint & Doodle

Haven't we all reached for a pen while on the telephone and started to draw? Absorbed in our conversation, we doodle forms, figures, lines, and squiggles. Sometimes we produce miniature works of art filled with whimsical patterns and doodles. This spontaneous type of art is what I tried to capture in this piece, except that instead of using a pen or pencil, I used acrylic paint.

Materials

2 blank stretched canvases, square

Acrylic paints or markers in light gray and light blue

Paintbrushes

Fine-line marker or ballpoint pen in black

Pencil

Sketch pad or paper

◄ Make yourself comfortable with a sheet of paper and a fine-line marker or ballpoint pen. Free-draw whimsical lines, curves, circles, and squiggles to get warmed up.

▶ On one of the canvases, using light pencil strokes, begin to draw and doodle a pattern of your choice. As you draw, allow forms and lines to emerge organically and order themselves in rows and patterns. Incorporate words or phrases into your designs, if you like. Once you have completed the design to your liking, ink over the lines and patterns with a black fine-line marker. Feel free to further accentuate the piece with heavy black marker. Repeat this process on your second canvas, as though continuing your design from one canvas to the other.

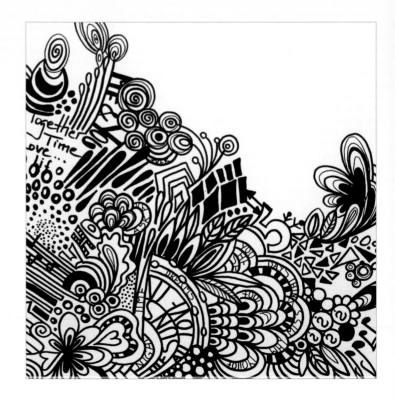

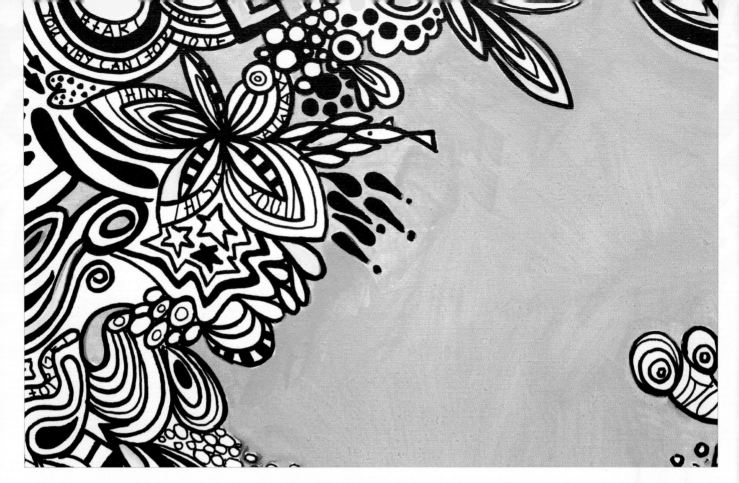

▲ Once the patterns are finished to your liking, add color in the remaining spaces around them with light gray, using either marker or paint.

Inspired Idea

Any color of your choosing can be used in this project. I considered orange briefly, and bright red and lilac also flitted through my head. Ultimately, I did not want to lessen the impact of the black lines, so the understated gray won out. But my choice should not take away your sense of freedom! Replace the gray with your own choice of color.

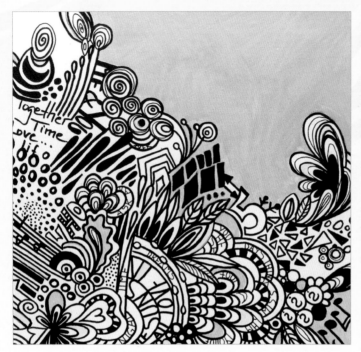
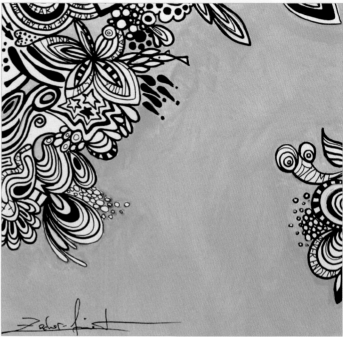

▲ Next, add a bit of light blue to various spots inside the pattern. I color in little bits around the whole of the pattern, but you may choose to color in entire areas. I chose light blue because it harmonizes well with the gray and has a soft cooling effect.

Inspired Idea

If you are looking to do a large-scale piece, consider extending the pattern across several small canvases. Alternatively, this is a great project to work on with others, such as friends or family members. Have each individual create his or her own pattern and then arrange the canvases into one single piece. I like this idea for a large family project.

▶ When my patterns are complete, I walk around both canvases and consider which orientation of the picture pleases me most. I decide on a vertical orientation, which has a nice flow from one canvas to the next.

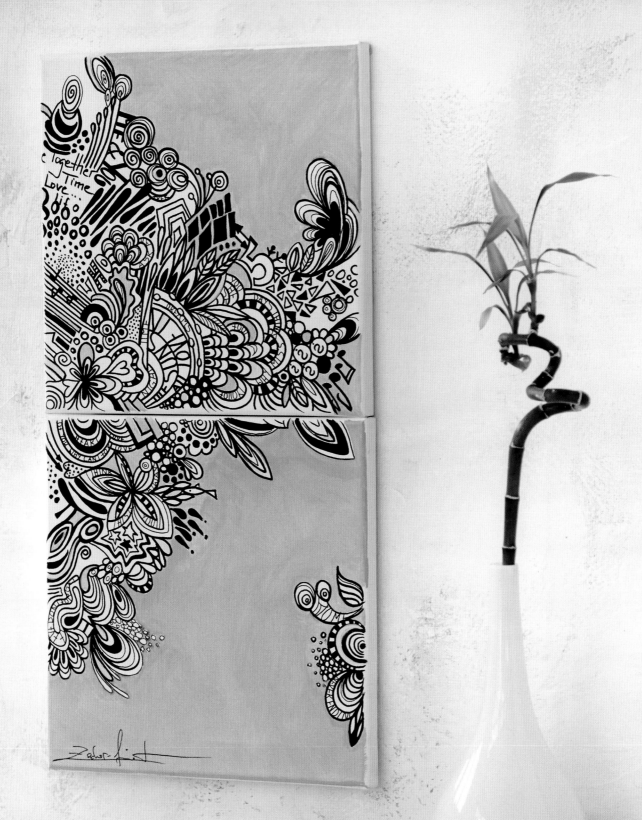

Cheerful Bouquet

I love painting blooms that are colorful, contemporary, and bright. Today I'm feeling a little silly and want to cherish my childlike, playful mood, so I approach this painting with a fun and carefree attitude.

Materials

1 blank stretched canvas, rectangular

Acrylic paints in yellow, red, turquoise, and titanium white

Flat paintbrush with synthetic bristles, medium

Old plastic credit card or piece of cardboard

Charcoal pencil, black crayon, or thick black pencil

◀ Since I'm not sure how my flowers in the vase will emerge, I don't want my first application of paint to be too precise. Instead I simply apply yellow and red in varying mixtures using the surface and edge of a credit card (a piece of cardboard also works). I apply turquoise to the area where I imagine the flower vase will be, adding a little yellow here and there to create varying shades of green.

◄ Continue to add yellow and red in areas to enhance the underpainting a bit more. Blend the colors into the areas applied earlier to reduce the appearance of hard lines, and allow the painting to dry before moving on to the next step.

▶ Using charcoal, crayon, or black pencil, draw the outline of the blooms, stems, leaves, and vase. My flower vase is slightly slanted for a whimsical touch. The bouquet hints at being blown in the wind. But, after all, when is nature perfectly straight?

If you do not care for how your drawing turned out, or you want to change something, you can wipe away charcoal lines with a damp cloth and start again.

While waiting for your painting to dry between steps, take some time to shake out your arms, dance, or go for a walk—all of which revives the body, mind, and spirit, and enhances creativity.

◀ Once happy with your outline, you can apply a fixative over your charcoal drawing so it does not smudge when you apply more paint. I decide not to do this, as when I think of children's drawings, they are rarely neat and are therefore full of the joy of life. I paint over more of the background with strong brushstrokes in the colors that I like. In the upper area, I apply red and blend it in; then I add more yellow to the lower half of the image, blending and creating a bit of a color gradient.

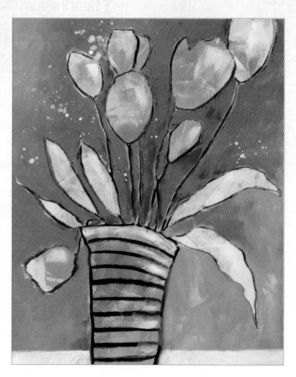

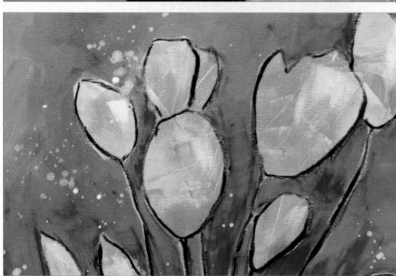

▲ For a bit of "sparkle," load your brush with a little white, and dab various areas of the flowers, leaves, and vase. With the brush still loaded, dip into a bit of water and flick toward the canvas to create random spots (above left). Finally, paint a white stripe at the bottom of the vase to add contrast (above right). Don't endeavor to make it perfectly straight—mine slants with vase and flower stems. Perfect!

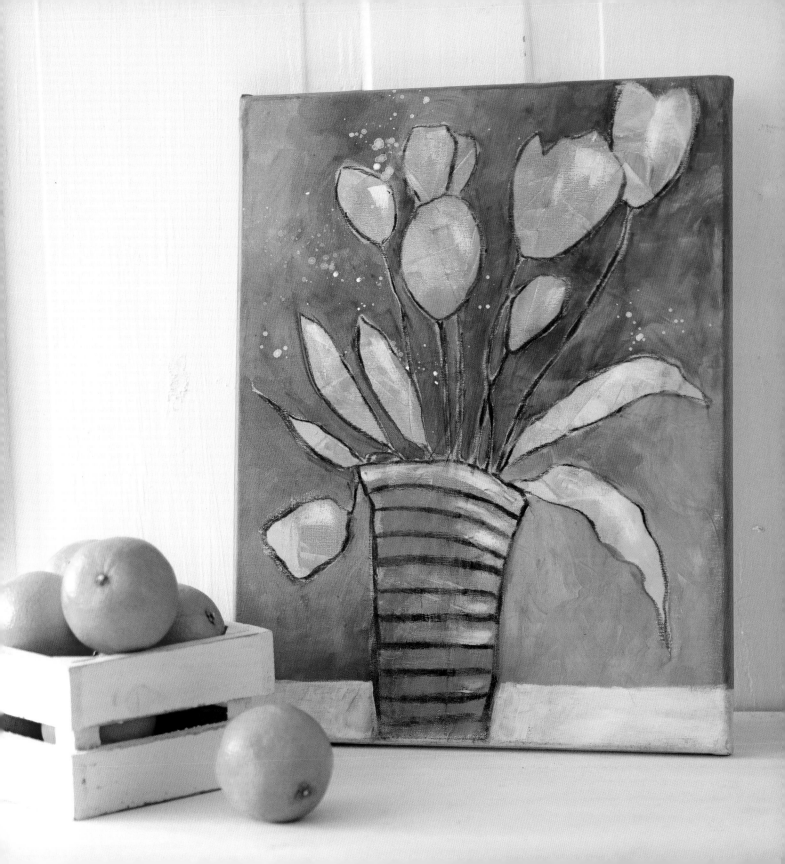

Sunny Side

Joy and liveliness, warmth and light, the first rays of the sun. These are the elements I wanted to capture in this painting. The combination of magenta and yellow—the very colors of a sunrise—produce wonderful orange tones, and it's even better that both light the other up. Other than choosing my color palette, I have no further idea in mind than to just get started!

▼ For the background, load a large brush with both magenta and yellow. Apply color to the upper third of the canvas, mixing the colors in some areas and leaving bright solid-colored brushstrokes in other areas. When I'm pleased with the result, I wipe the brush clean and apply a thick, swoosh-like stroke in magenta with one sweeping movement to the right of center.

Materials

1 blank stretched canvas, square

Acrylic paints in yellow, magenta, and titanium white

Large brush with synthetic bristles for the background

Flat brush with synthetic bristles, medium

Round brush with synthetic bristles, small

White pastel pencil or chalk (optional)

◄ With yellow and mixtures of yellow-magenta, paint around the thick magenta-colored stroke with a large flat brush, pulling in and blending some additional solid magenta in various spots to create soft transitions. Allow the background to dry for about 15 minutes before moving on to the next step.

While the background is drying, take an opportunity to stick your nose into some fresh outside air—especially if it is light and sunny!

▶ Load the flat brush with a dab of titanium white, blotting it on a paper towel until there is scarcely any paint on the bristles. Apply the white along the left edge and top of the darker magenta stroke, and blend softly. The white softens the stroke and produces the first impression of light.

▲ With a dry brush and a very small mixture of yellow and titanium white, paint over the yellow areas in the background. Repeat this process with a small mixture of magenta and titanium white over the orange tones. I continue this process until the background has softly blended notes of yellow, orange, and pink. Feel free to paint over as much or as little of the background as you like using this method; once finished, you will have a beautiful variety of color.

▲ The thin layer applied in the previous step dries rapidly, making it possible to keep working without interruption. I decide to intensify the light with the dry-brush application of titanium white, creating the sun's "rays." Using my finger, I blend each ray so that it softly fades into the background.

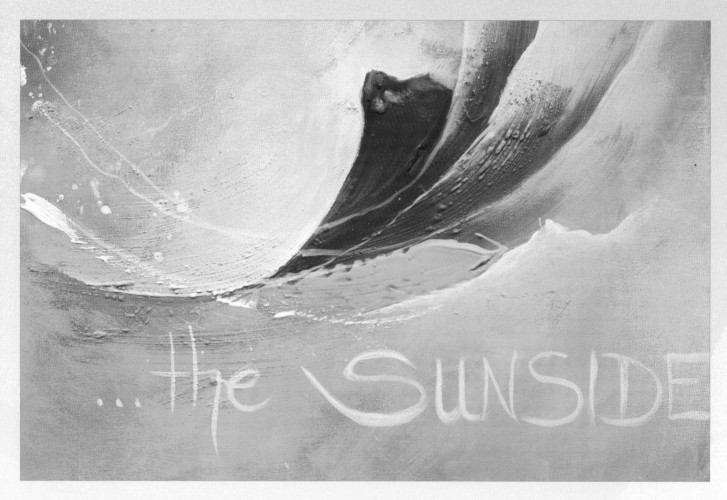

▲ I apply a few random paint spatters with white to add a carefree liveliness to the painting, which also corresponds to my mood. Finally, I add the words "the Sunside," to the bottom of the painting using a round brush and a bit of titanium white paint diluted with water. That is the final touch, which will bring light and sun into my dwelling, even on overcast days.

Inspired Idea

To personalize your finished painting, select a favorite word or phrase that has special meaning to you. For longer text, use a soft pastel pencil or chalk instead of a brush and paint, both of which can be wiped off, if necessary.

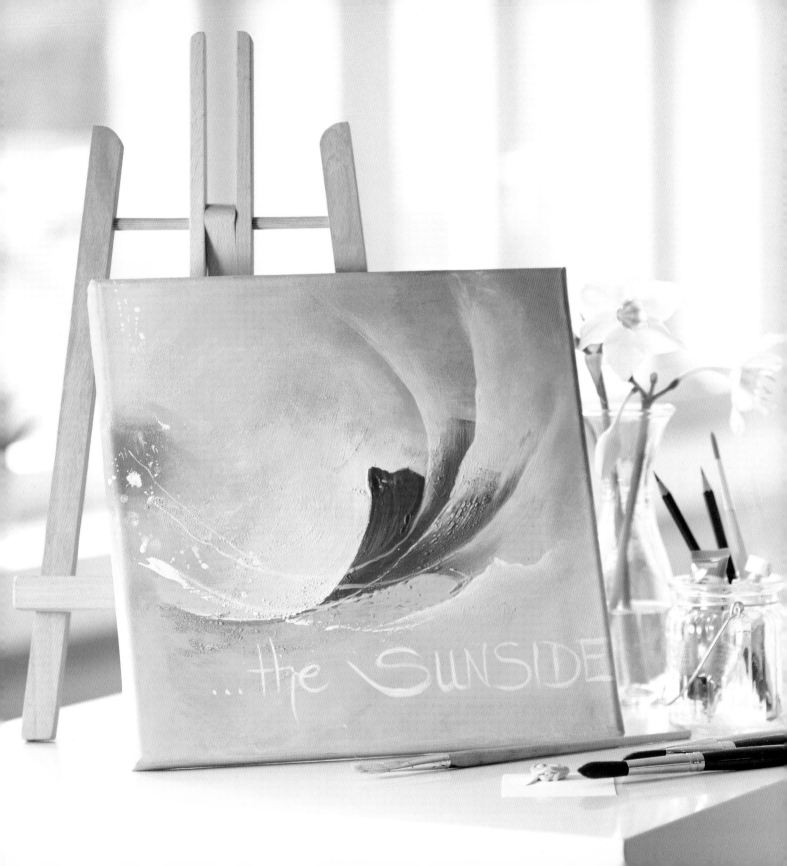

Poppies

I was inspired to paint this picture from a sunset radiating warm orange and poppies with pronounced blooms. Instead of using paintbrushes, I decide to experiment with a palette knife for its many compositional possibilities.

Materials

1 blank stretched canvas, rectangular

Acrylic paints in orange, yellow, and titanium white

Palette knife, medium

Soft pencil

▲ Apply orange and yellow to the canvas with the palette knife, blending the colors with the knife's edge.

For the first three steps, do not allow paint to dry between applications. Instead, work quickly as you apply new layers.

▶ With the palette knife, blend some white into the still-damp background, leaving the outer edges darker. Do not apply a lot of pressure while blending with the knife. Use the tip or edge of the knife to create long vertical lines of varying lengths down the center of the canvas; these are the flower "stems." Then use the knife surface to "flatten" them into the background. Lightly blend again.

◀ With a soft pencil, add names, words, phrases, or marks of your choosing in the still-wet paint. These do not have to be legible, as the purpose is to add a decorative flourish; however, you may choose to introduce personally meaningful messages too. Allow the painting to dry.

▶ Load the knife with a generous amount of yellow. Using quick movements, apply thick, heavy strokes to the tips of the flower stems; these are the blooms. Continue to add several thick applications until your flower blooms are to your liking. Create a combination of large and small blooms, or little buds, if you like. Next load your knife with a generous amount of orange and repeat the process, barely blending the orange into the bottom of each yellow flower.

29

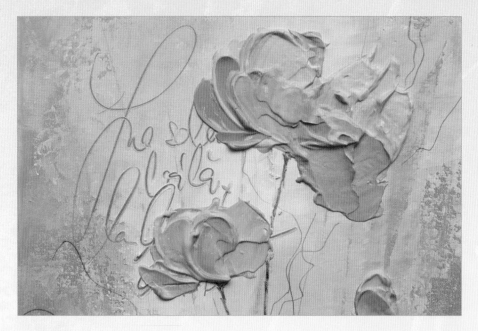

◀ Using a soft pencil, draw into the stems of the flowers to create dimension. Continue to draw in several light and dark squiggles and scribbles to suggest branches and grasses.

◀ For one final touch, I paint a horizontal line of large circles across the lower third of the canvas using a mixture of yellow and orange. And because I am determined not to use a brush at all today, I use my fingers to paint the pattern.

Inspired Idea

If you like the feel of paint on your hands, experiment with finger painting for this or any of the projects in this book.

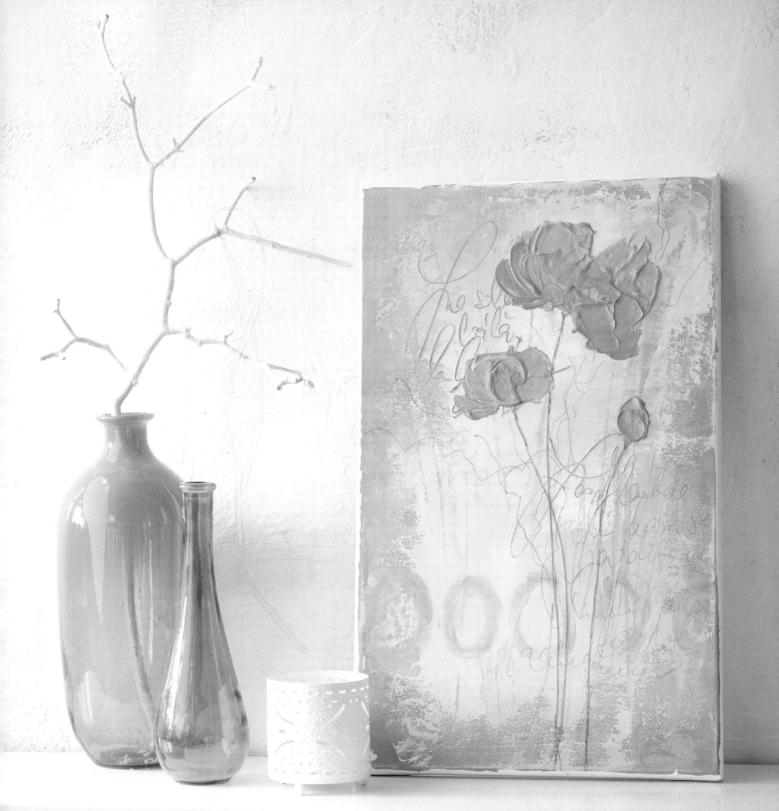

Colorful Butterfly

Materials

1 blank stretched canvas, rectangular

Acrylic paints in blue, magenta, yellow, titanium white, black, or any colors of your choice

Old plastic credit card

Brightly colored pastel crayons

What could be better than to be light and free as a butterfly, making the day beautiful with iridescent color? For this project, I do not need a painted background. Instead, I create colorful forms on plain white. I want my butterfly to fly unobstructed, taking my thoughts with it on its dreamy wanderings through the air!

Using a pastel crayon, lightly draw a few basic contour lines to indicate the butterfly. Dilute a bit of blue paint copiously with water, and spatter the watery paint mixture on a few random areas around the canvas.

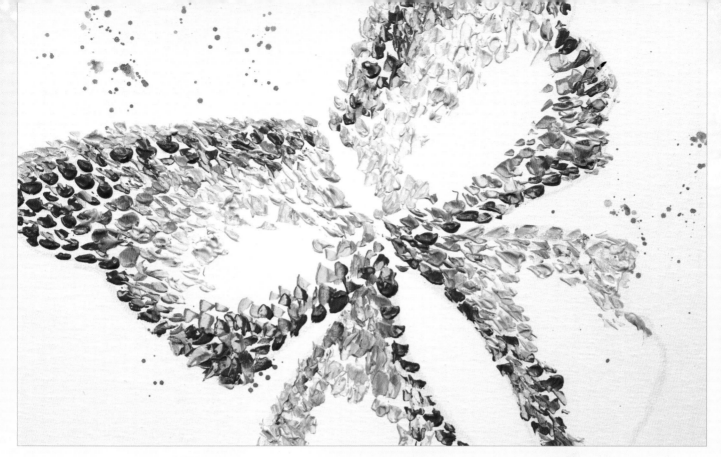

▲ While the paint spatter dries, cut a narrow strip from the plastic credit card to create a miniature "spatula." Continue to cut strips to create additional spatula strips of varying widths. Load one of the spatulas with a generous amount of color and begin dabbing paint into the contour lines, starting in the middle and applying paint outward, forming the shape of the wings. Apply one color at a time as many times as you like until you have a complete outline. Repeat the process, loading a new spatula with another color, continuing to work around the outline.

Inspired Idea

Although my butterfly's wings consist of thicker dabs of paint, you may experiment to see what you prefer. Should the dabs of color be blended in with each other, or do you prefer more definite patterns?

▶ I use two colors to fill in the middle of the wings. Group colors together according to your preference.

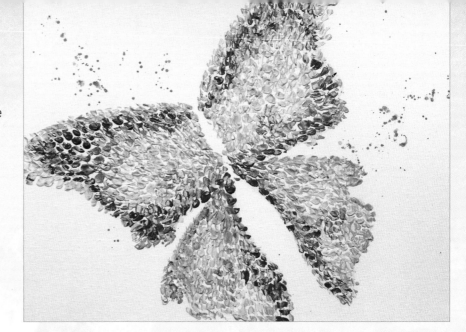

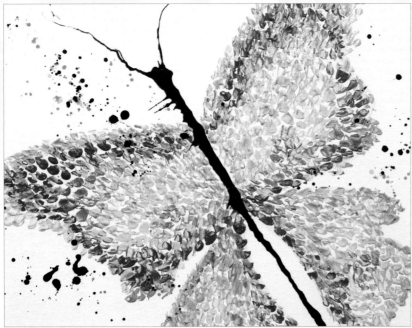

◀ With the wings filled in, I am ready to add the butterfly's body and antennae. Dilute black paint with a bit of water. Dip one of the card spatulas into the black paint mixture and begin dripping it carefully into the form of the body until it fills out the space to your liking. Allow a few black drops to fill in the some of the areas of white canvas, if you like.

Inspired Idea

Paint drips and dabs can be used to make any favorite subject more whimsical and colorful. Bright colors look especially radiant on a black background!

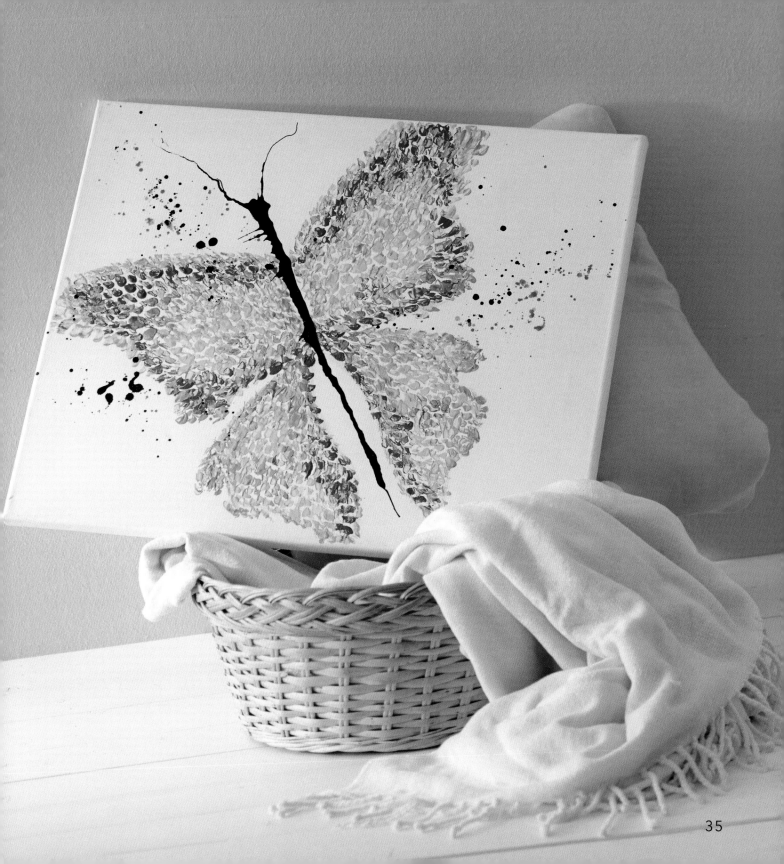

Dreamy Summer Garden

Materials

1 blank stretched canvas, square

Acrylic paints in magenta, dark or phthalo green, and titanium white

Flat paintbrush with synthetic bristles, medium

Inspired by a peaceful and pretty summer garden, I wanted to paint a soothing picture using a limited color palette. There are no sharp contours or clearly defined forms. Experiment with working freely to create a garden that inspires you.

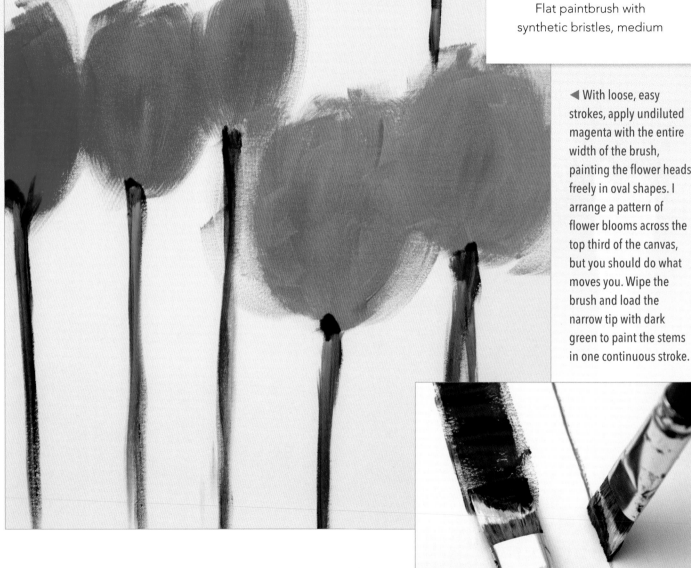

◀ With loose, easy strokes, apply undiluted magenta with the entire width of the brush, painting the flower heads freely in oval shapes. I arrange a pattern of flower blooms across the top third of the canvas, but you should do what moves you. Wipe the brush and load the narrow tip with dark green to paint the stems in one continuous stroke.

► While the blooms and stems are still wet, I begin working on the background, pulling in bits of color from the flowers and blending them into the background. Experiment with various mixtures of magenta and white, plus a bit of green, followed by more green mixed with white; then blend in streaks of color from the flowers. I continue to fill in the background using various gradations of color that I like.

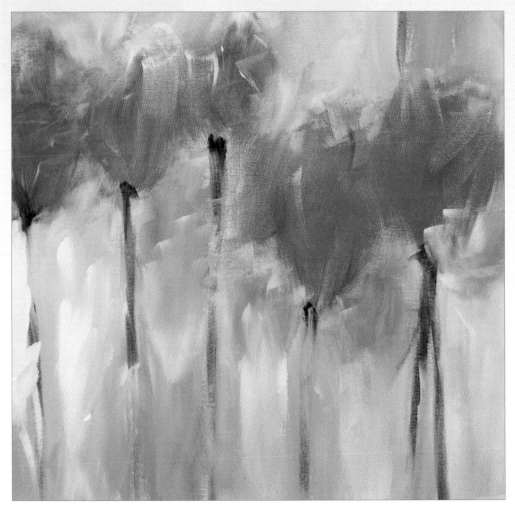

◄ Next add in strokes of pure titanium white along the tips of the blooms and between the flower stems to help create a soft, blurry effect.

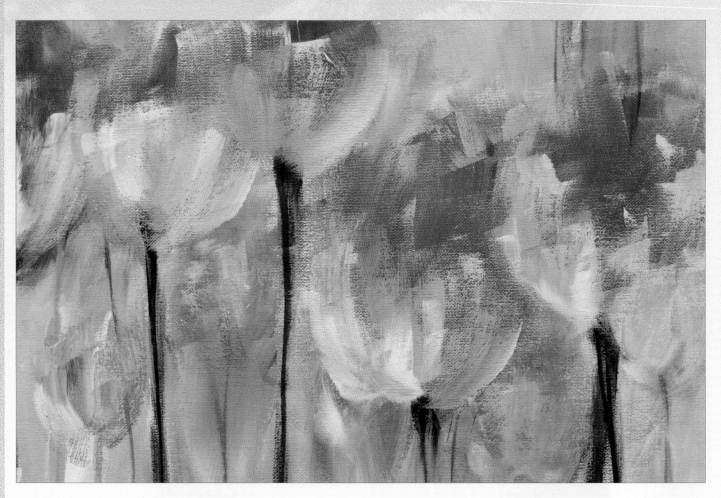

▲ Add a bit more titanium white over the flower blooms, blending softly into the magenta. Load the narrow side of the brush again with the dark green and paint over the stems once more. With a bit of green and titanium white, lightly stroke in more vertical lines along the stems to suggest grass. Continue to fill in the space and add in a few hazy flower blooms and stems into the background. Load the brush with one final mixture of magenta and titanium white, and paint into blooms once more to add a bit more depth and dimension. To finish, dilute white with copious water and spatter a bit of the mixture randomly onto the painting with the brush.

Inspired Idea

When changing colors between paint applications, wipe the brush on a piece of scrap paper, rather than clean it with water. This produces unexpected color mixtures, which are a little gift, as it's difficult to create such varied colors on purpose!

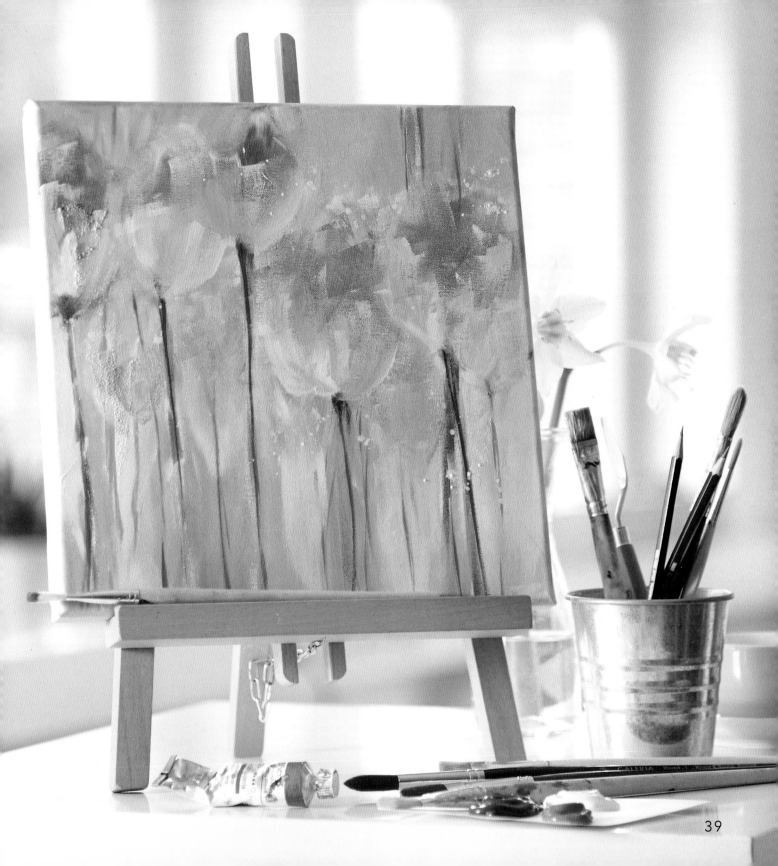

Love & Dreams

Materials

1 blank stretched canvas, square

Acrylic paints in magenta, titanium white, violet, and black

Flat brush with synthetic bristles, medium

Round brush with synthetic bristles, small

Straightedge ruler (optional)

Crayon or watercolor pencil (optional)

Often when I feel like writing, my thoughts go back to stories from my life. I usually don't have enough concentration for writing long text. So I combine words and paint and allow the words to shape my motif. Although I am not a calligraphy artist, if my words look even as good as a street artist's, something at least halfway decent should be the result!

▲ Create a dreamy shade of pink for the background by mixing magenta and titanium white directly on the canvas with the brush using horizontal strokes. Add more paint until you are happy with the shade. Let the paint dry.

◀ Load the flat brush in violet and write the words on the canvas in a linear arrangement in large block letters. If you are concerned with keeping your lines of text straight, use a ruler to measure the spacing and use a watercolor pencil to add guidelines. You can wipe the lines away later.

Allow the letters to "run off" the edges of the canvas. A little disorder is preferable to trying to make a "perfect" painting.

Inspired Idea

For a more dramatic effect, paint the background dark red, and paint your lettering in white or black. Today my mood is girlie, so I'm choosing pink. What color will you choose?

◀ Next, mix black and titanium white to create a shade of gray. Load the round brush, and write the same words over the block text in script. To prevent the gray lettering from looking flat, and to add a bit of contrast, paint over some of the letters, alternating between strokes of black and white. When finished, allow the letters time to dry.

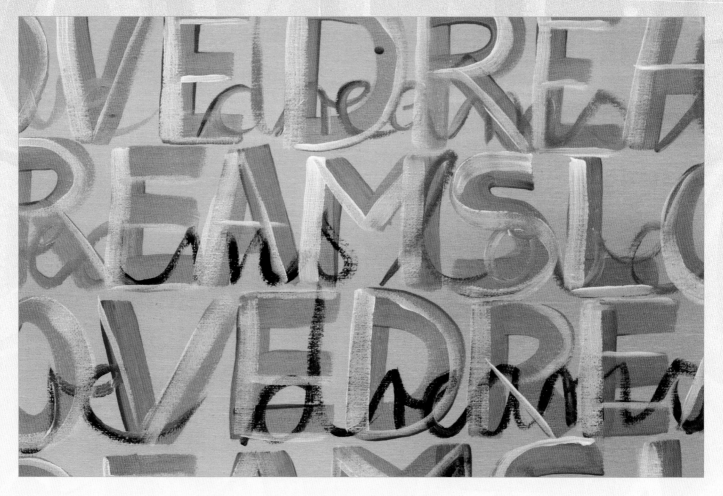

▲ As a finishing touch, load the flat brush with titanium white and paint over the letters once again, using the broad and narrow sides of the brush to give each letter a bit of dimension.

Remember: There are no rules!
The canvas is your personal stage
of expression!

Inspired Idea

Practice painting in different lettering styles and experimenting with various color schemes. There are endless possibilities for decorating single letters. Lettering-motif paintings make ideal gifts, since they can be created in individual and personal ways.

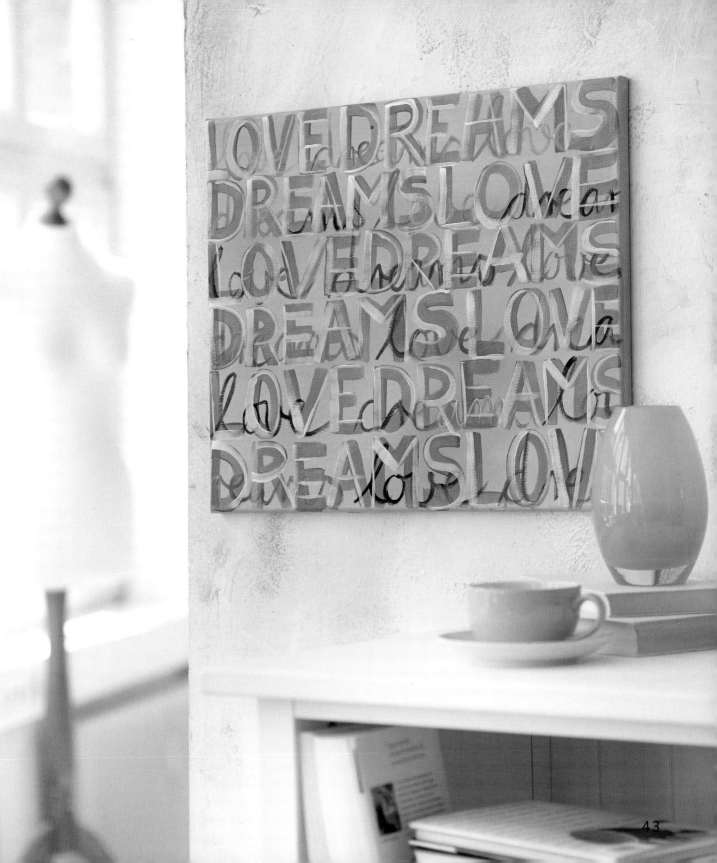

Delicate Peonies

Materials

1 blank stretched canvas, rectangular

Acrylic paints in magenta, titanium white, light blue, yellow, and green

Old plastic credit card

Palette knife, medium (optional)

With their soft colors and airy blooms, for me, painting flowers is a brief holiday from everyday life. I can almost smell the lovely fragrance of the flowers when I give in to the mood of the picture.

▼ I have chosen happy and vivid tones for their playfulness. Mix various combinations of magenta and white to create several shades of pink. Use the short side of a plastic credit card to apply large strokes of color to the canvas; then wipe the card clean and apply light blue. Continue to add alternating vertical and horizontal strokes of pink and blue until the background is filled.

If you only have dark blue on hand, you can lighten it up by mixing it with titanium white.

Paint applied with a credit card or palette knife has a lively, textural effect.

▶ For the blooms, apply magenta in a goblet shape using the side of the plastic card and a bit of pressure on initial application, releasing the pressure as you stroke upward. This will result in a thinner layer of paint with texture. In some places, mix yellow and magenta on the flowers to produce shades of orange. Allow the blooms to dry so the next layer of paint will not mix with it. Since the layer is thin, it should dry quickly.

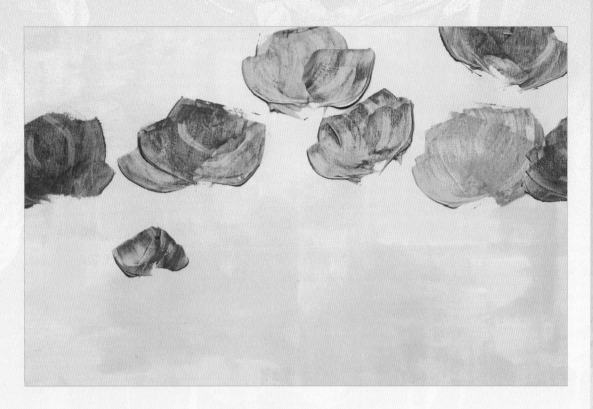

◀ Using the same technique, continue adding new flowers and painting over some flowers already on the canvas, this time using the mixtures of magenta and titanium white. Use a corner of the card to paint some smaller yellow flowers, mixing in a bit of white to them.

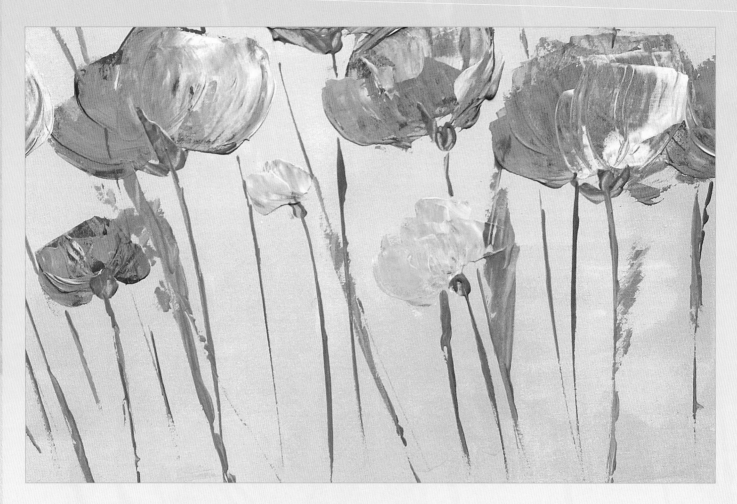

▲ To give the stems and leaves a fresh, lively effect, mix the green with some yellow and a bit of titanium white. Apply the bases of the stem with one corner of the card, allowing small traces of color to blend in with the blooms. To apply the stems, dip the longer side of the card in the paint mixture and drag it at an almost 90-degree angle, starting at the bloom and dragging it down in a line. Continue to add stems to the flowers and a bit of grass in various places to give the illusion that the peonies are part of a flower meadow. Add some leaves as a finishing touch.

Inspired Idea

Feel free to follow my color suggestions or choose your own colors according to your mood. I have painted this same theme on different days—once in a happy mood, once in a dreamy mood, and once in a contemplative mood. It is remarkable how my moods influence the outcome of my artwork.

When I observe these little flowers, it occurs to me that a few small butterflies would look perfectly natural among them.

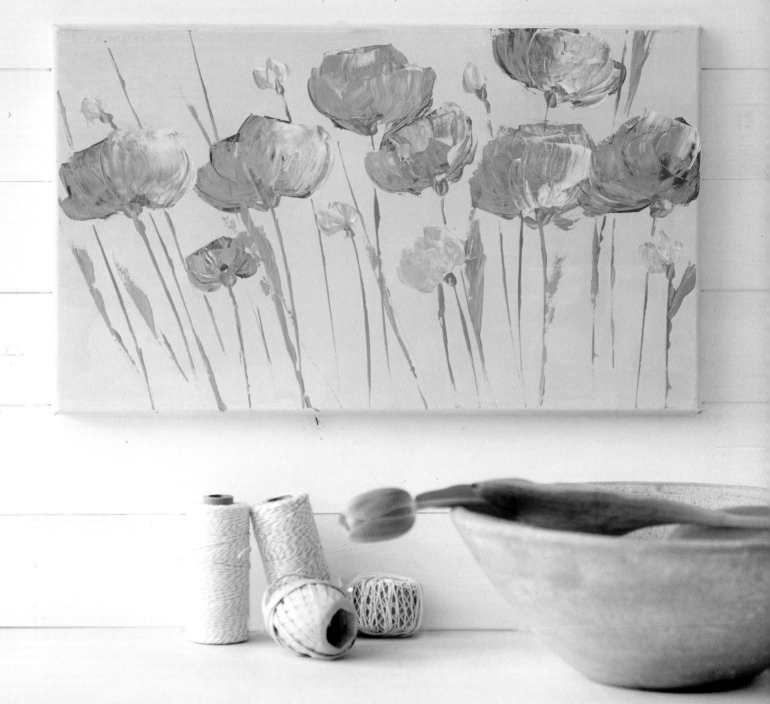

Green Fields

Sometimes I cannot decide what kind of art that I want to make. Should I create art with bold, colorful patterns or with soft color progressions? Fortunately, the canvas offers the freedom not to decide, but instead to combine several creative possibilities!

Materials

1 blank stretched canvas, square

Acrylic paints in dark green, yellow, and titanium white (or other harmonizing colors)

Masking tape

Flat brush with synthetic bristles, medium

Scissors or box cutter

Pencil (optional)

Straightedge ruler (optional)

▲ Working in vertical movements, apply dark green, yellow, and titanium white alternating in various mixtures to the canvas. While allowing the paint to completely dry, cut several strips of masking about 2½ inches in length.

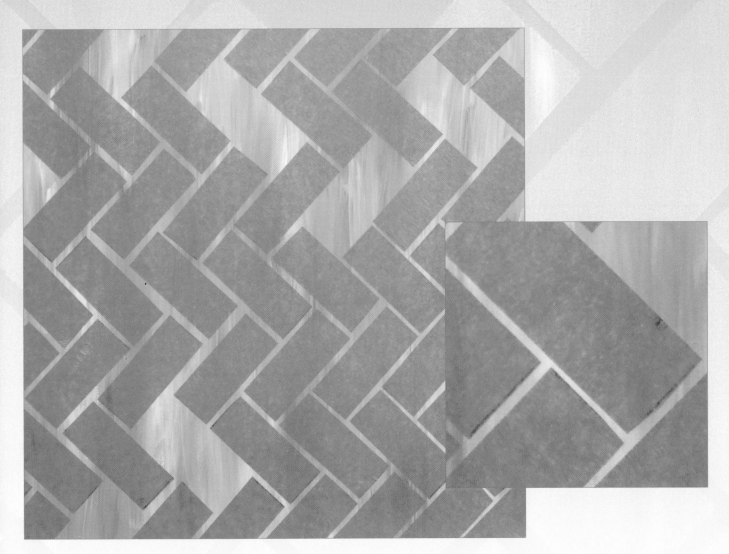

▲ Apply the strips to your canvas in a pattern of your choosing. I opt for a diagonal composition, positioning my first strip of tape in the top left corner of the canvas diagonally, and then orienting the other strips of tape to that. Feel free to use a straightedge ruler and pencil to help map out the pattern first. The masking tape will protect the color you laid down in the first step.

If possible, choose masking tape in a color that matches the color palette of your painting. This will help you envision more clearly what the final pattern will look like before you apply the final layer of paint.

49

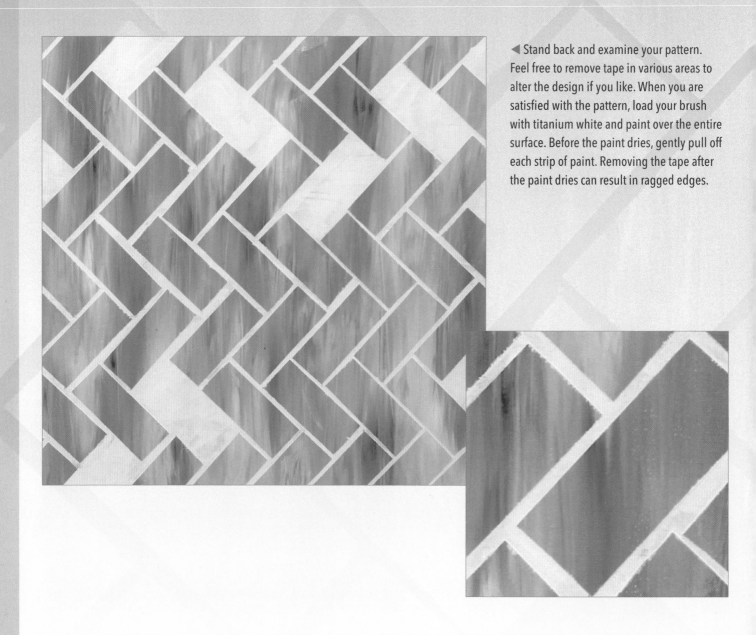

◄ Stand back and examine your pattern. Feel free to remove tape in various areas to alter the design if you like. When you are satisfied with the pattern, load your brush with titanium white and paint over the entire surface. Before the paint dries, gently pull off each strip of paint. Removing the tape after the paint dries can result in ragged edges.

It can be tricky to lift the tape with your fingers when the paint is wet. To assist in this process, carefully slide the tip of the scissors under the edge of the tape; then use your fingers to pull it away.

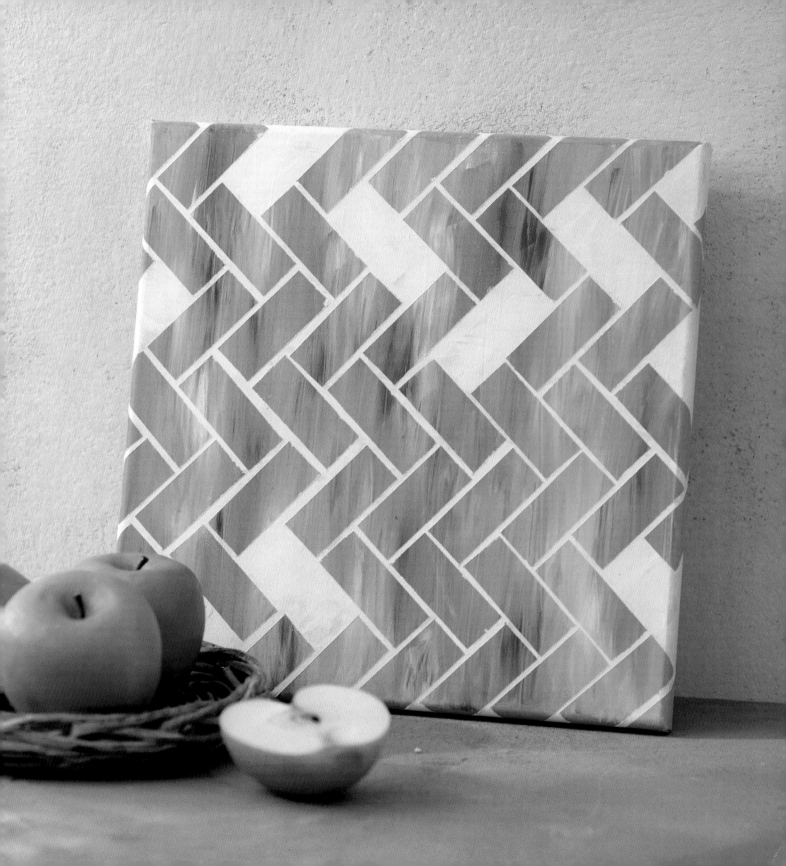

Hearts

Hearts are a well-loved theme, and most artists have a particular connection to them for their simplicity and symbolism. A large single heart on a canvas can make a powerful statement, but I like the idea of lots of little hearts to celebrate all of the beautiful things that have occurred in my life. Paint as many hearts as you like for each beautiful story that comes to your mind.

Materials

1 blank stretched canvas, square

Acrylic paints in titanium white, red, yellow, turquoise, and magenta

Flat brush with synthetic bristles, medium

Palette knife, old plastic credit card, piece of cardboard, or other color "shaper"

Bright pastel crayons, regular crayons, or watercolor pencil

Graphite or color pencil

Cotton swabs

◀ Using the color shaper tool of your choice, apply paints in generous amounts, alternating colors and mixing them into each other in various combinations. Lose yourself in the creation of a colorful background for as long as you like. Allow time to dry.

Think about the beautiful things that have happened in your life. Who or what has touched your heart? Write your thoughts down in your art journal. This will make the art process even more meaningful.

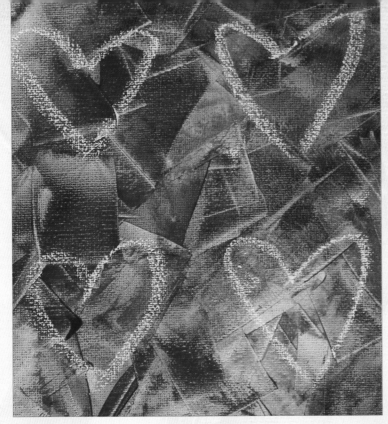

◄ Use a pastel crayon to draw hearts in a design of your choice on the background.

▼ When the hearts are all in place, paint around them over the background with a flat brush loaded with titanium white, crisscrossing strokes and allowing bits of the background to show through in places.

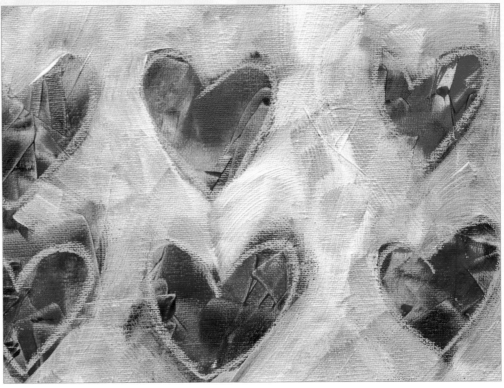

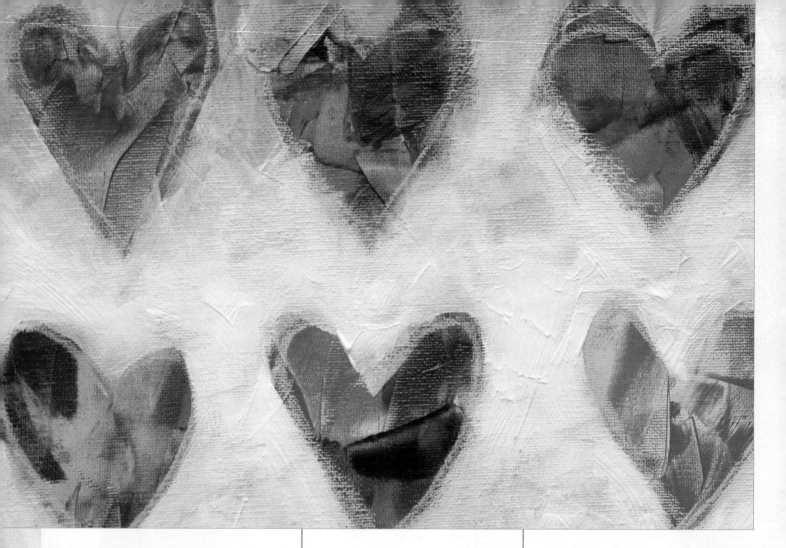

▲ Repeat the application of titanium white once more or until you are satisfied with the result. In order to create a little movement, I do not paint the second layer of white all the way to the top. Instead I end it at the bottom tips of the hearts in the first row. This leaves a stripe of color at the top. Allow the painting to dry completely.

Inspired Idea

Choose the colors for this project freely according to your imagination. A monochromatic scheme, such as various shades of blue, or black and white, looks modern and contemporary. Or use gold and silver for an elegant and sophisticated feel.

▶ To finish up, draw rough freehand borders around the hearts with graphite pencil. Alternatively, you may use colored pencils for a brighter effect. I add a few more pencil squiggles and add a few words at the edge of the painting: "little hearts of love." Feel free to write your own personal message. Use a cotton swab to wipe away pastel lines that are still visible, and the small colorful declaration of love is complete.

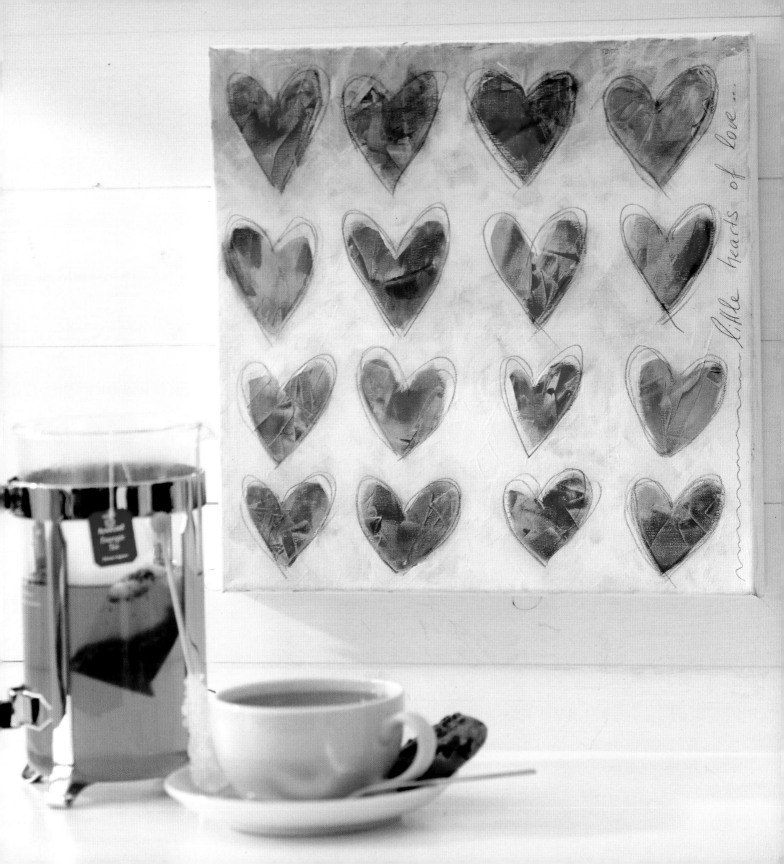

little hearts of love ...

Bamboo in the Wind

Materials

3 blank stretched canvases, square

Acrylic paints in titanium white, light green, and olive or dark green

Round brush with synthetic bristles, small

Bamboo is a marvelous theme in art. It is easy to illustrate and paint and offers many possibilities. You can lose yourself in tiny details, simply suggest the theme, or use strong brushstrokes if that suits you. You don't have to decide what you will do ahead of time—let the process unfold naturally.

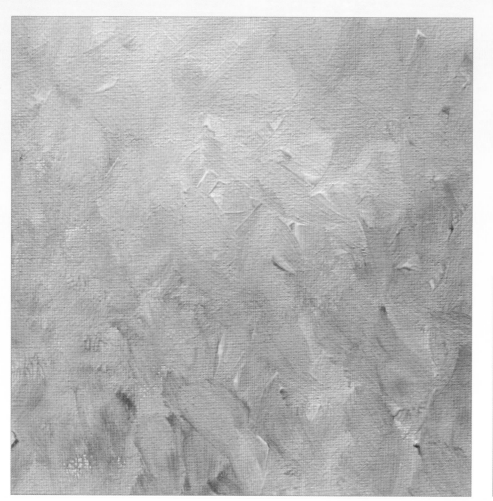

◄ Load your brush with light green and dark green, and apply to the canvas. Add in a bit of titanium white to lighten some areas as desired. While the first canvas is drying, repeat the process on the second canvas. When complete, move on to the third canvas.

Before you start painting the bamboo, experiment rotating the canvases so that the darker green spots are in different locations: top, bottom, or side.

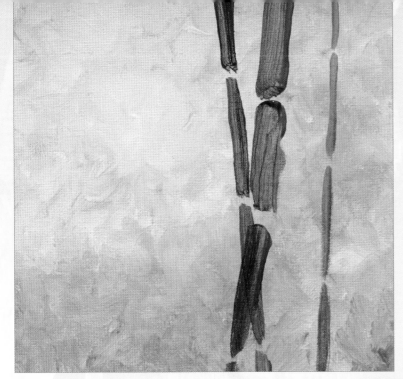

◀ Load both greens onto the brush and position the brush at a slight angle. Using little pressure, paint a series of vertical lines, stacking one on top of another, similar to a dashed line. This is the first stem. Continue the process, painting a series of thick and thin stems, intersecting them. This is the beauty of a round brush: it allows for several types of line widths and forms.

▶ Add some leaves, painting droplike forms of varying lengths and with irregular points. For the pointed leaves, I load my brush with dark green, applying a bit of pressure and lifting it from the canvas in a relatively rapid motion to the side. For narrower, smaller leaves, use less pressure when beginning the stroke. I paint the leaves freely in small star-like clusters next to each other.

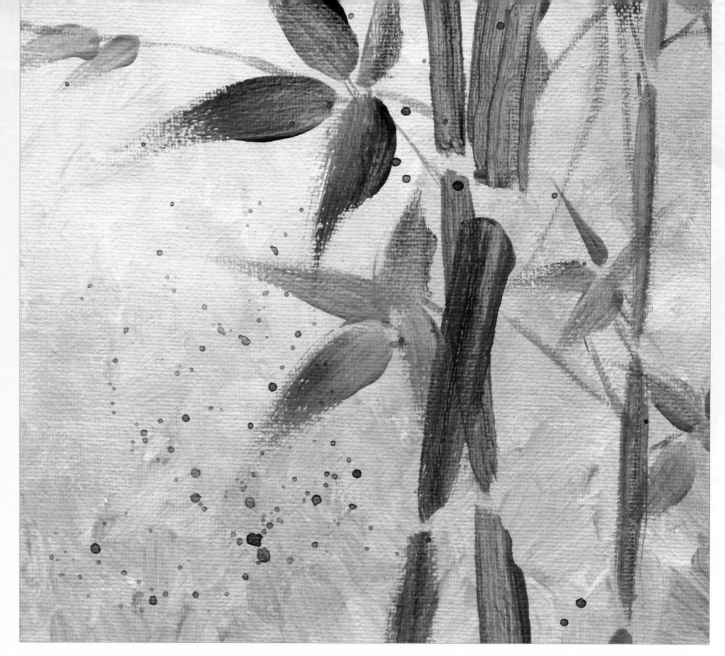

▲ Dampen the brush and shape the tip into a point. Paint fine lines to join the stems to the leaves. These tender branches are made with green mixes that are slightly diluted with water. Finally, add a few spatters with the brush and diluted green. Repeat to your liking on the other two canvases.

Inspired Idea

The bamboo motif can be painted in varied color combinations. If you like red and orange, you can paint the bamboo fiery and laden with energy. In gray tones the bamboo acquires an upscale feel.

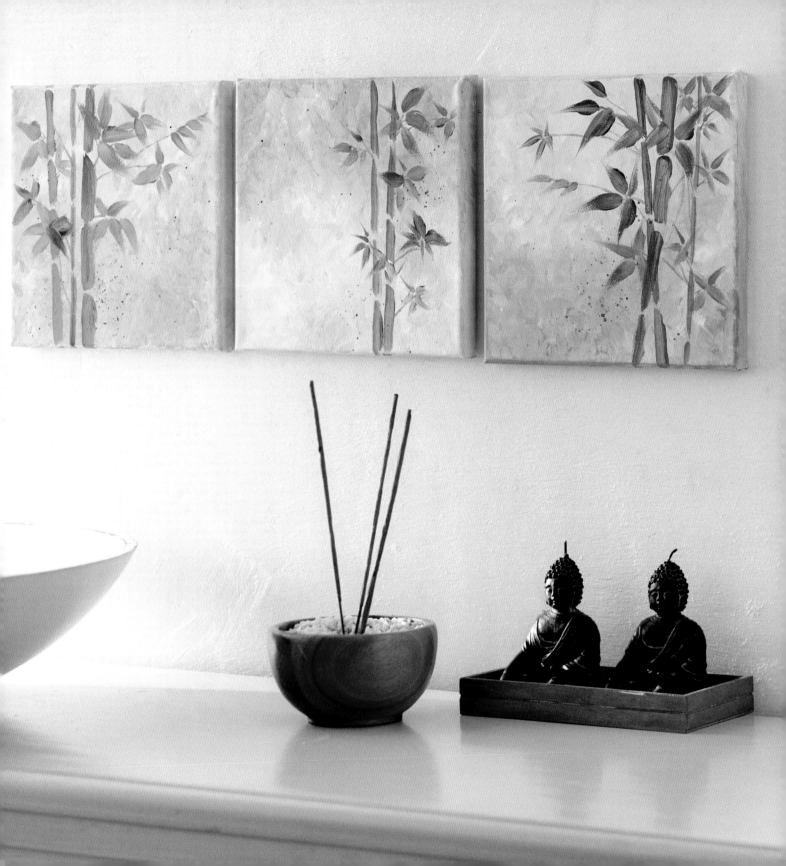

Dandelions

Dandelions have a delicate, airy feel. After all, a single breath is enough to set the small stamens on their journey into the wind; thus, these plants have a dreamy quality. (Doesn't it seem as if the tiny seeds could carry dreams through the air?) Representing a dandelion in a painting isn't as difficult as it might seem at first. The first steps are done quickly, and small details complete the task.

Materials

1 blank stretched canvas, rectangular

Acrylic paints in dark green, yellow, and titanium white

Flat brushes with synthetic bristles, large and small

Roll of paper towels (for making patterns)

◄ For this project, you will use two different shades of green: dark green and a lighter green mixed from dark green and yellow. Dampen the flat large brush with both greens and apply large sweeping brushstrokes on the canvas to create the background. Before the canvas is dry, roll the paper towels over the still wet layer to create an imprinted pattern.

◀ My background is a bit too busy, so I apply one more thin coat of the green-yellow mixture over the canvas, leaving just a bit of the pattern still visible. Allow to dry before moving on to the next step.

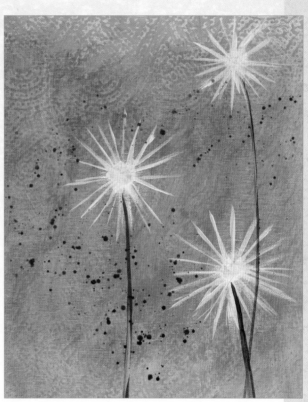

▶ With the small brush, paint each bloom as a solid circular center in titanium white. Next, softly and irregularly, drag lines outward from the center with a dry brush. With dark green, paint long thin stems and add a few spatters of green diluted with water. Dab small touches of white to the stems, creating a small reflection of light.

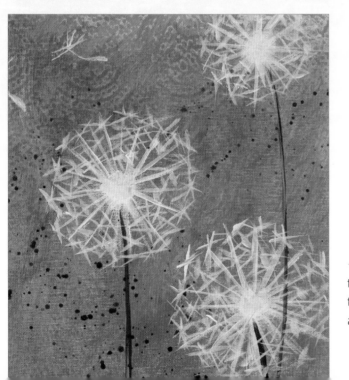

◀ Load the small brush with a bit of titanium white and dab three tiny intersecting strokes at the end of each white point. Distribute these "stars" evenly around the flower and paint a few floating around the buds as though they are drifting through the air.

61

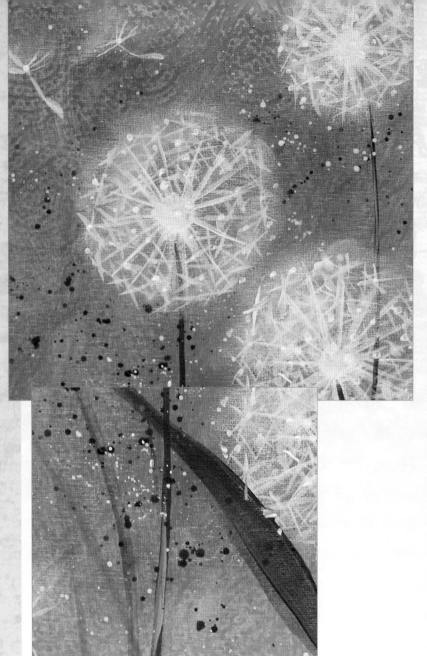

◀ Dab a little white onto a dry brush and dot the excess paint onto a piece of paper. Gently rub the paint in a circular motion inside the empty spaces of the dandelion blooms to make them appear "fluffy." Load the brush with white diluted with water, and flick a few white spatters around the painting. Add a few white dots in and around the tips of the flowers.

▶ To finish, paint in more grasses and leaves in alternating shades of green. Dab a paper towel into white and blot on a paper; then dab the top and bottom of the painting. Add a bit of white script on the lower right side of the painting for a sense of balance and harmony.

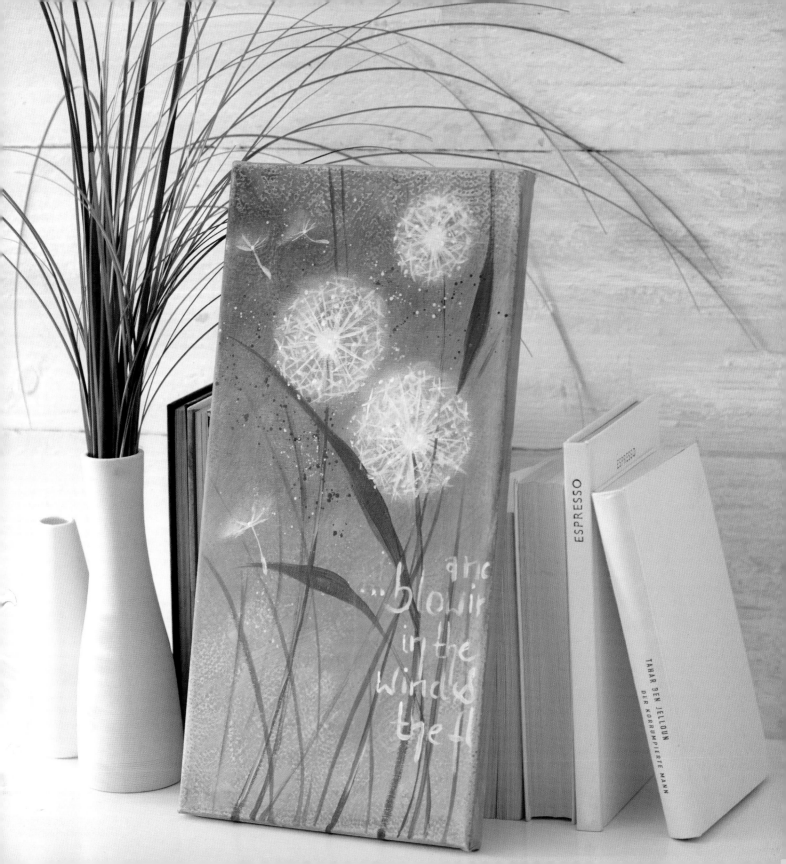

Fields of Color

Materials

1 blank stretched canvas, rectangular

Acrylic paints in titanium white, magenta, yellow, red, blue, and dark and light green

Flat brush with synthetic bristles, medium

When I'm in a creative mood but do not know what I would like to paint, I simply start with blocks of color. An entire painting can consist of color and nothing else, which can lead to other new paintings later. That's why beginning with blocks of color is always a great way to start a new piece—even if you don't know what you want to paint.

◀ Start with dark colors over which lighter colors can be added later. My choice leans to green tones, since they can be completed with sunny yellow. I lightly emphasize the upper third of the painting with a horizontal red stripe, but otherwise I do not focus on how to divide the color fields. For dramatic effect, I add one more band of red to the bottom of the canvas. When the canvas is completely filled with color, allow the background to dry so that the colors applied do not mix with successive coats of paint.

▶ Block in more color with various mixtures of blue, green, and orange, allowing some areas of the original background to show through. I also add a few new forms, and leave visible brush strokes on the canvas. I simply follow the "melody" of colors and trust that everything will turn out beautifully. While the paint is still wet, I use the tip of the brush handle to add script lettering.

Inspired Idea

Between steps, observe your work from a distance. What pleases you? What is missing? What is too dark? What is too light? What do you want to keep? What do you want to paint over? This is a voyage of discovery. Turn away from the painting for a few minutes and then look at it again with one quick glance to observe things that you may not have noticed before. You might find that something that you didn't like before does not bother you anymore.

◄ I would like everything to look a bit brighter, so I add more green into the middle yellow area. I also lightly paint over a bit of the lettering so it recedes a little but still remains visible. I paint bright accents in pink and draw in the color fields again by making small circular patterns with the tip of the brush. I finish this painting with a final accent in red.

Inspired Idea

This type of painting lends itself to neutral tones that can be mixed in varying gradations with white. You can find wonderful color inspirations in catalogs, fashion magazines, and fabric swatches.

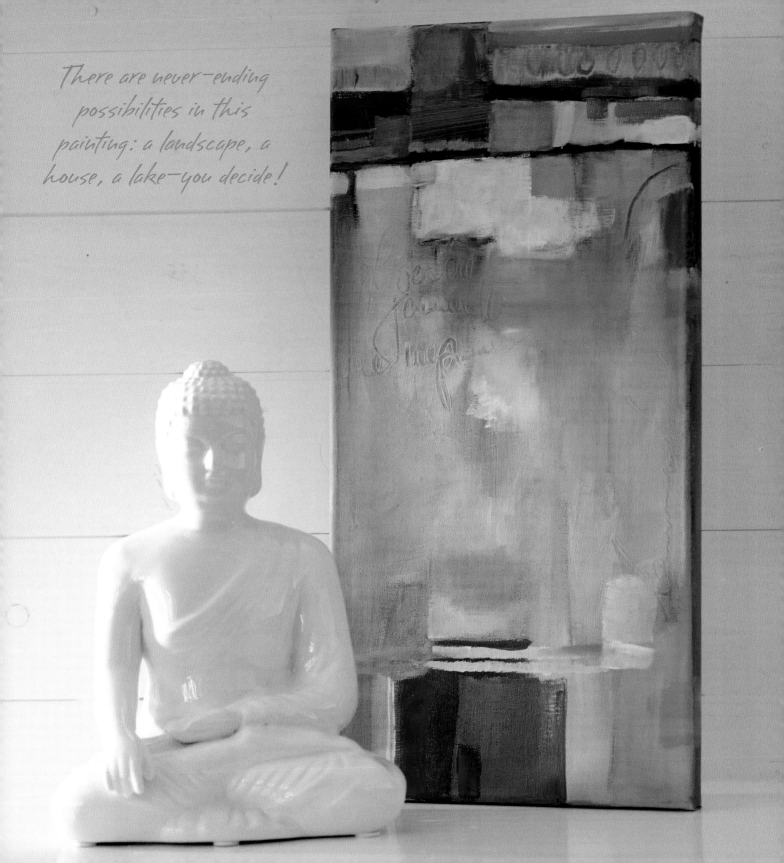

There are never-ending possibilities in this painting: a landscape, a house, a lake—you decide!

Playful Flowers

Today was a happy day—the first rays of the sun tickled me awake early this morning, and the smile has not disappeared from my face since. Therefore, I've decided to paint a bright, colorful summer picture.

1 blank stretched canvas, rectangular

Acrylic paints in cerulean, yellow, orange, titanium white, and magenta

Round brush with synthetic bristles, large

Household sponge

Black India ink

Bamboo quills (or shish kebab skewers or small sticks)

◀ Dip the sponge in cerulean and dab paint on the canvas. Dab in layers of white, adding in more white gradually as you work farther down the canvas. This creates a nice even gradation of color. Allow time to dry.

▲ Paint the first white petals with the round brush and a generous application of paint. Place each thickly painted petal closely next to one another in a circular pattern. Without washing the brush, dab orange and yellow into the center with the tip of the brush.

▶ Add two more white flowers of different sizes near the first. Load the brush again, this time with magenta, and paint more flowers in the shapes of spirals, small dots, or whatever you please! Allow time to dry.

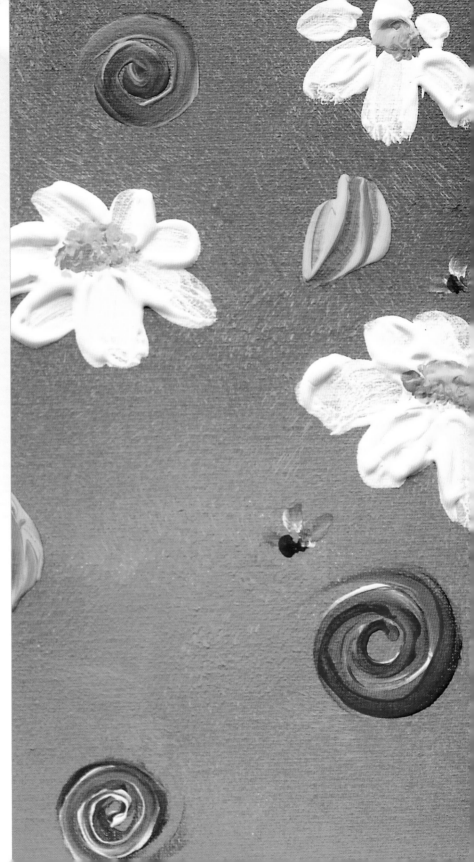

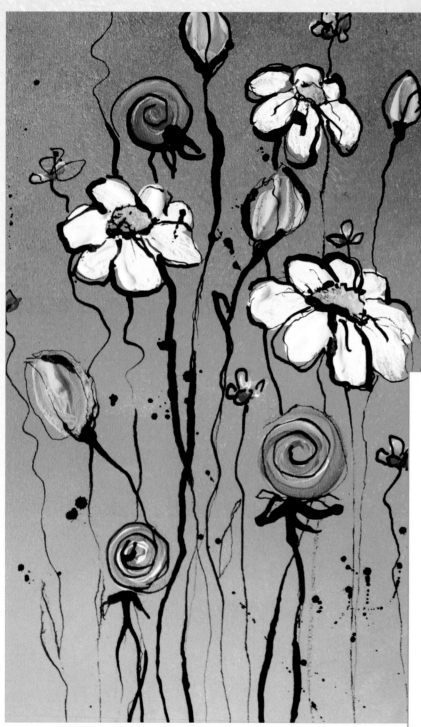

◄ When the flowers are dry, use the quill and ink to add the stems and outline the flowers for greater impact. Using a quill and ink allows you to have a bit of fun, as you can draw, drip, drizzle, and spatter the ink to charming effect. The vitality of India ink distinguishes your flower stems from perfectly drawn or painted lines. There are no limits to the creativity and fun you can have with this project!

Inspired Idea

Have fun experimenting with different shapes for flowers—triangles, circles, ovals, and stars make for fun painting!

If you are unsure about using India ink, take some time to practice using it on paper first. If you prefer your lines to be more controlled and orderly, simply use a fine-line marker or another type of waterproof black ink pen instead.

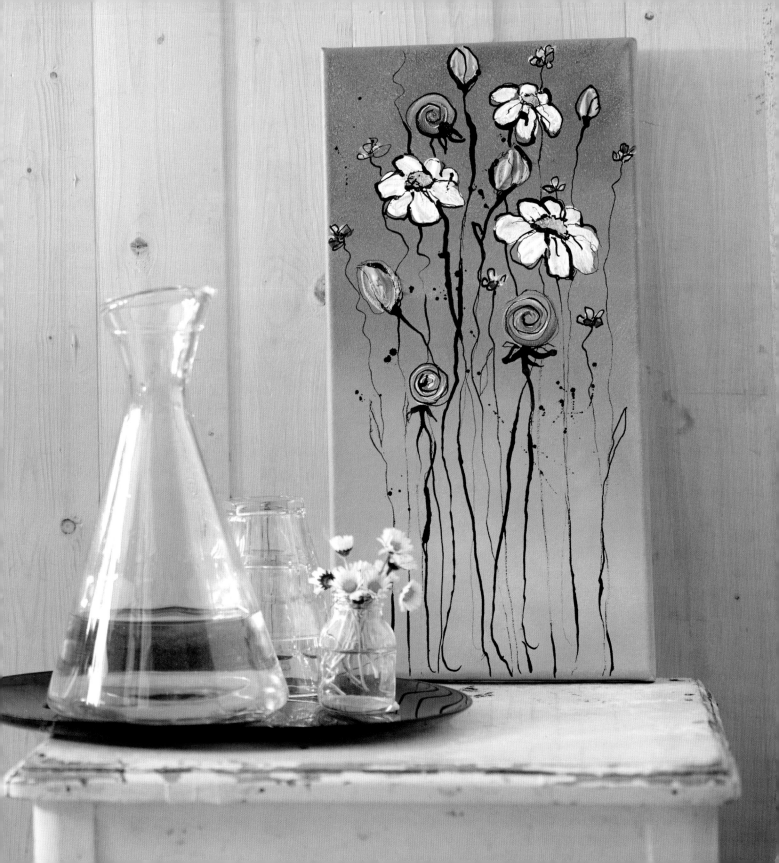

Blue Motion

Some days I don't want to create anything tangible. Instead, I prefer to just move paint around on my canvas with no definite image in my mind's eye. This piece was an experiment for me. Instead of focusing on the end result, I stayed in touch with the process, which inevitably turned into something special.

Materials

1 blank stretched canvas, rectangular

Acrylic paints in dark blue, titanium white, turquoise, and yellow

Gel medium

Palette knife

Flat brush with synthetic bristles, medium

◀ Using the palette knife, mix gel medium with blue paint until it has a pasty consistency. Apply a generous amount of the color mixture to the middle of the canvas, dividing and spreading it with the knife. Play with the paint through a variety of movements: dabbing, smoothing, spreading, etc. Because the paint is thick, it does not dry too quickly, allowing time to experiment with no hard and fast rules.

▲ Mix dark blue with a bit of white to create a light blue color. Apply this mixture with the palette knife around the darkest blue strokes created in the first step. Blend light into dark with the tip of the knife where the colors meet. Smooth the light blue in thin horizontal and vertical strokes to give the painting a harmonious sense of movement.

▲ Continue to smooth out the lighter blue strokes and work the thick dark blue area a bit more, spreading and lifting out the paint so it isn't as thick as when it was first applied.

◀ Continue to work on the dark blue, stroking up to form little blue "waves." Apply a few bright accents with yellow and turquoise in quick, careful movements. To prevent each color from blending together too much, take a break and allow the dark blue and accent colors in the middle to dry.

▶ Mix a bit of white with turquoise and dab a dry brush into the mixture, blotting the excess on a paper towel. Apply the paint softly and sparingly around the dark blue waves in outward strokes. This creates a softer transition between the dark blue and light blue surrounding it. For this step, too little paint on the brush is better than too much. Little by little, continue to work over the outer contours of the dark blue center to create soft color transitions, applying increasingly darker shades of turquoise as you move to the edges of the canvas.

◀ Use the brush to spatter bits of yellow and blue, diluted with water, to the upper left area of the blue waves.

▶ Finally load a little bit of white on the dry brush, dabbing off any excess on a paper towel. Tap a little over the raised dark blue areas. This adds interest and contrast.

KUSMI TEA
1867
Label Impérial

Blue Buddha

I do not always make enough time for meditation in the traditional sense. But meditation has many faces for me—to be so deep into a project that I forget the world and have space to let my thoughts run free is also meditative. Often, when I yearn for this tranquil state of mind, I paint a meditative theme, such as the Buddha featured here.

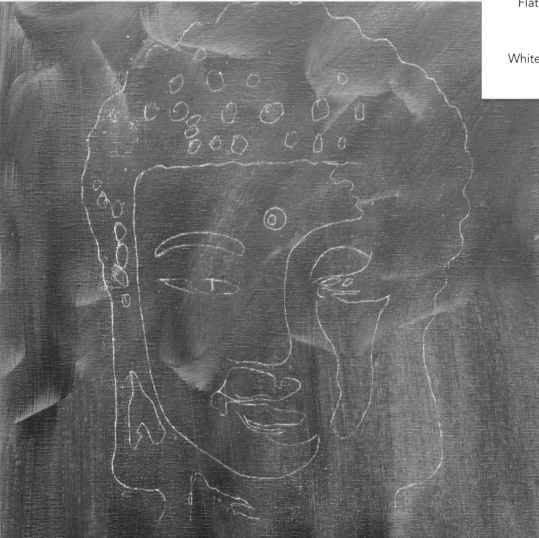

◄ Paint your canvas in your darkest shade of blue (in this case, teal) and allow the background to dry. Once dry, use a white pastel pencil or chalk to sketch the image on the surface.

▶ Mix teal or dark blue with titanium white. The shade does not have to be substantially brighter than the painted background. Load a dry brush with the mixture and dab on a paper towel or piece of paper. Then apply to the contours of the sketch. Allow the darker background to show through in places, if you like.

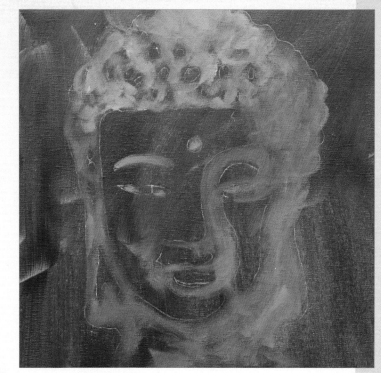

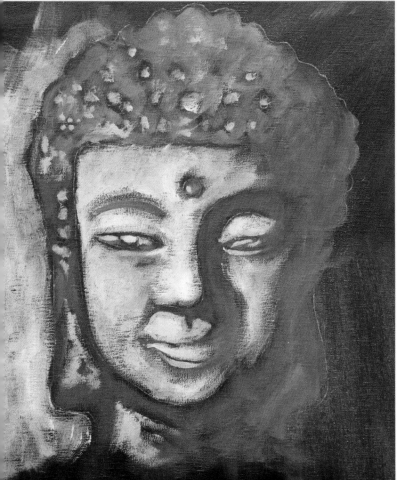

◀ Mix teal with more titanium white for a lighter shade of blue. Using the same dry brush technique, apply the paint to areas where you'd imagine light casting a glow on the face and background. Alternate between the light blue and dark teal to emphasize the features, such as the nose, eyes, eyebrows, and mouth.

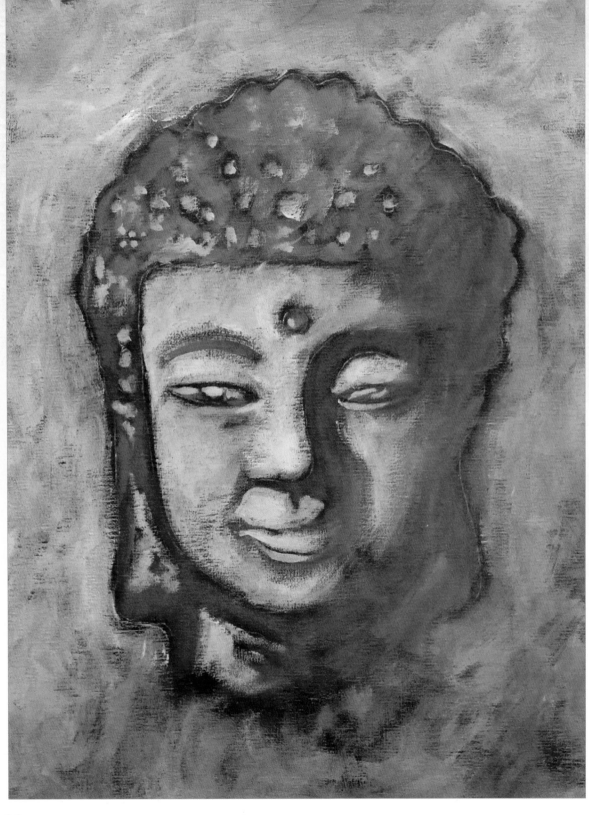

◄ When the Buddha's features are complete, fill in the background with the light blue using uneven, flowy brushstrokes, and adding any other touches to the background that you might like. Finish by outlining the contours of the head and face lightly with a white pastel pencil.

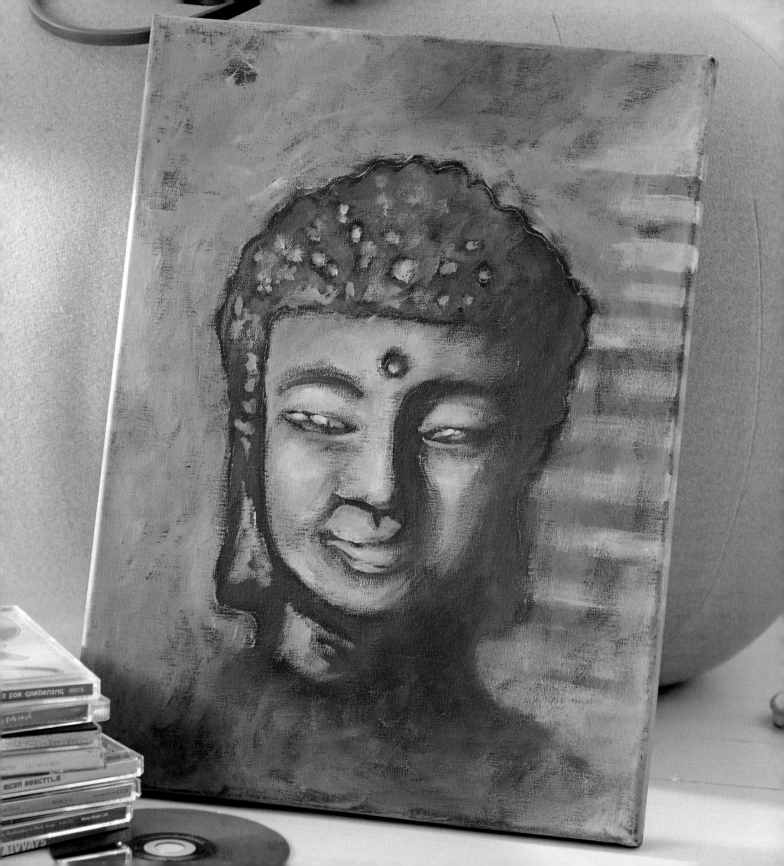

Poetry in Flowers

I love working with acrylic mediums, like structural paste for the texture that it gives the paint. I love paintings that have both flat and raised surfaces for their variety and interest.

Materials

1 blank stretched canvas, square

Acrylic paints in cerulean, magenta, titanium white, and black

Light structural paste (alternatively, gel medium colored with titanium white)

Flat brush with synthetic bristles in your chosen size

Teaspoon

◄ Generously apply various mixtures of cerulean, magenta, and titanium white in brushstrokes that crisscross one another. After the first coat of paint, the canvas looks relatively wild. How lovely!

Don't overthink how to start your painting. Just begin to paint and the rest will follow.

◀ Wipe the brush on a paper towel or a piece of paper and go over the canvas again, continuing to mix the colors until you are pleased with the outcome.

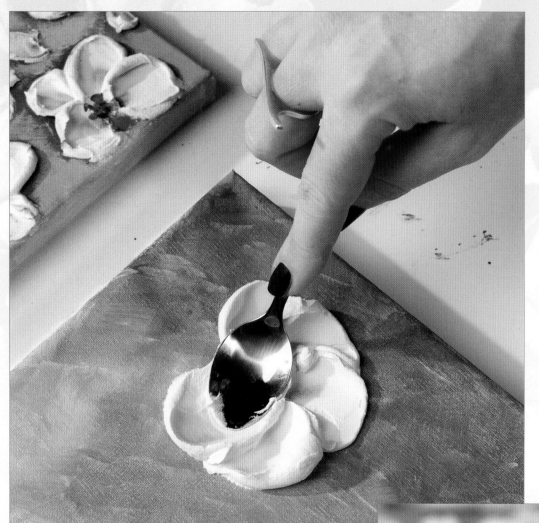

◀ Use a teaspoon to create flowers with thick, raised round petals. Lift a generous amount of structural paste with the convex side of the spoon, and apply the first flower on the still-damp canvas.

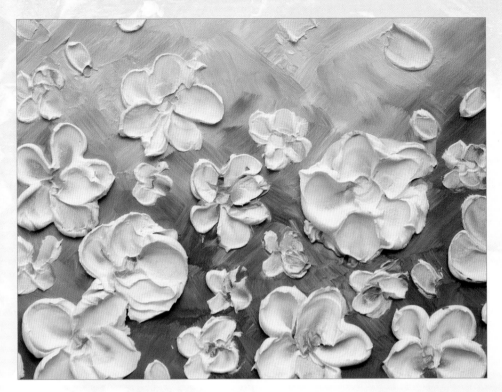

◄ Continue to apply petal after petal in circular form, for three-dimensional flowers of varying sizes all around the canvas. Accent the flowers with a few stray "floating" petals.

Practice the spoon application technique on a piece of paper before going straight to the canvas. This will help you refine your technique, if necessary.

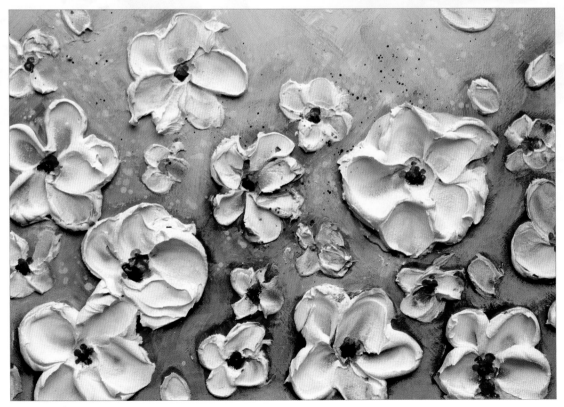

◄ Continue to add smaller flowers between the larger flowers until you are happy with the result. Then allow the painting to dry overnight. When dry, use the brush to add small dots of violet and blue to create flower buds. With a dry brush, paint thin coats of light blue, mixed from cerulean and titanium white; and lilac, mixed from magenta and titanium white, over the background; grazing the edges of the blooms lightly.

To me, the marvelous color of this painting contains poetry, and right away I think of a title: "Flower Poetry." Sometimes life is just that simple.

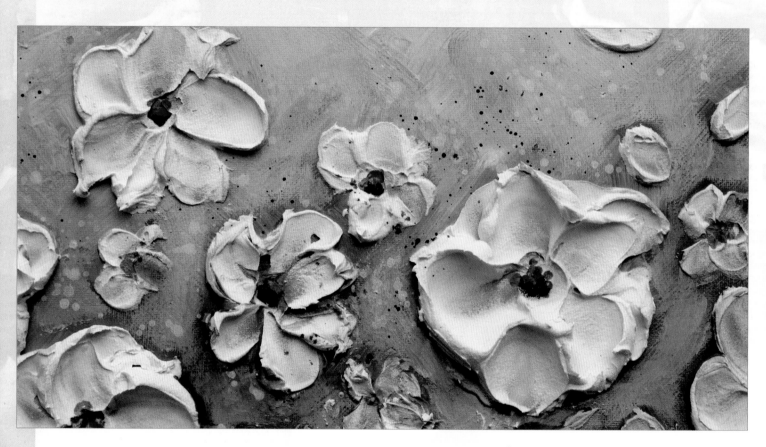

▲ Dilute black with water and add tiny dots to the flower buds to add some depth; then spatter some of the diluted black on parts of the canvas.

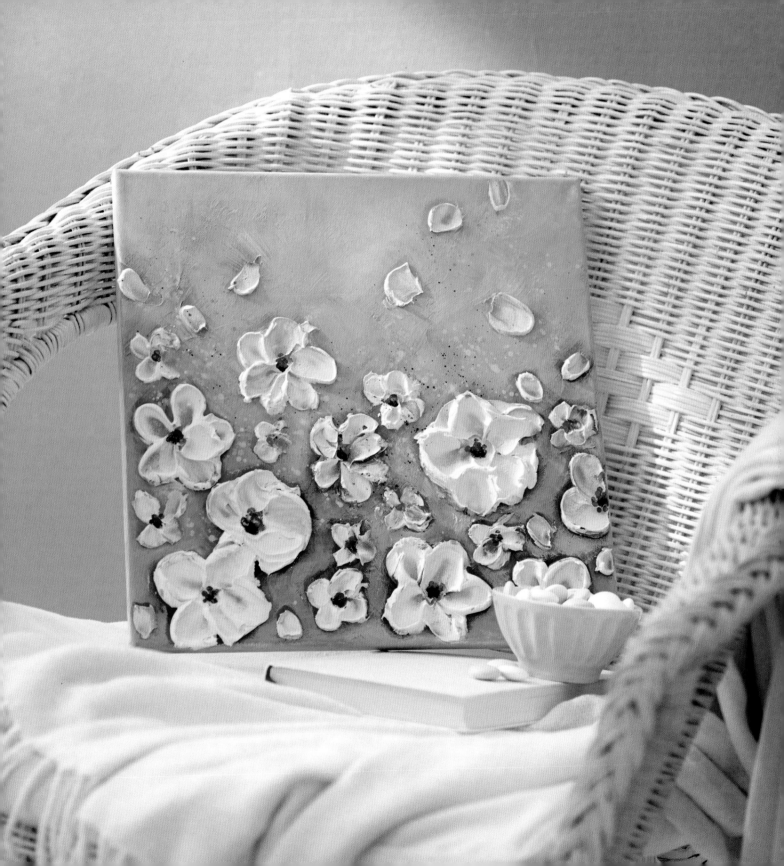

Radiant Rays

On days when I am seeking peace and clarity, I prefer to paint less playfully. At these times, graphic images with clean lines and spaces in balance suit me best.

Materials

1 blank stretched canvas, square

Acrylic paints in crimson, orange, and titanium white

Flat brush with synthetic bristles, medium

Narrow masking tape

◀ Use the masking tape to design the "rays," setting the midpoint in the lower left part of the frame to suggest a sunburst, as well as to give the painting more visual interest.

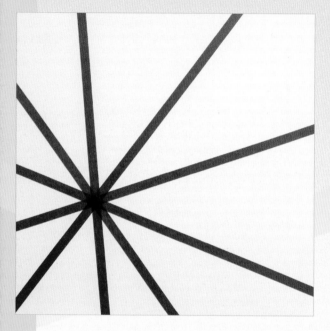

▼ With the masking tape firmly in place, paint inside two of the rays with crimson. Create various shades of orange from dark to light by mixing different combinations of orange with titanium white. Paint inside the other rays according to your taste. When you are happy with the result, and before the paint dries, carefully peel the masking tape off.

Inspired Idea

For variation, feel free to experiment with different color combinations for this project. Combining cool shades of blue and green, or purple and lilac, make for beautiful results. For a more vibrant piece use primary or complementary color combinations.

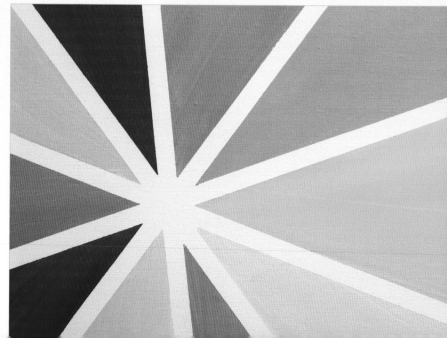

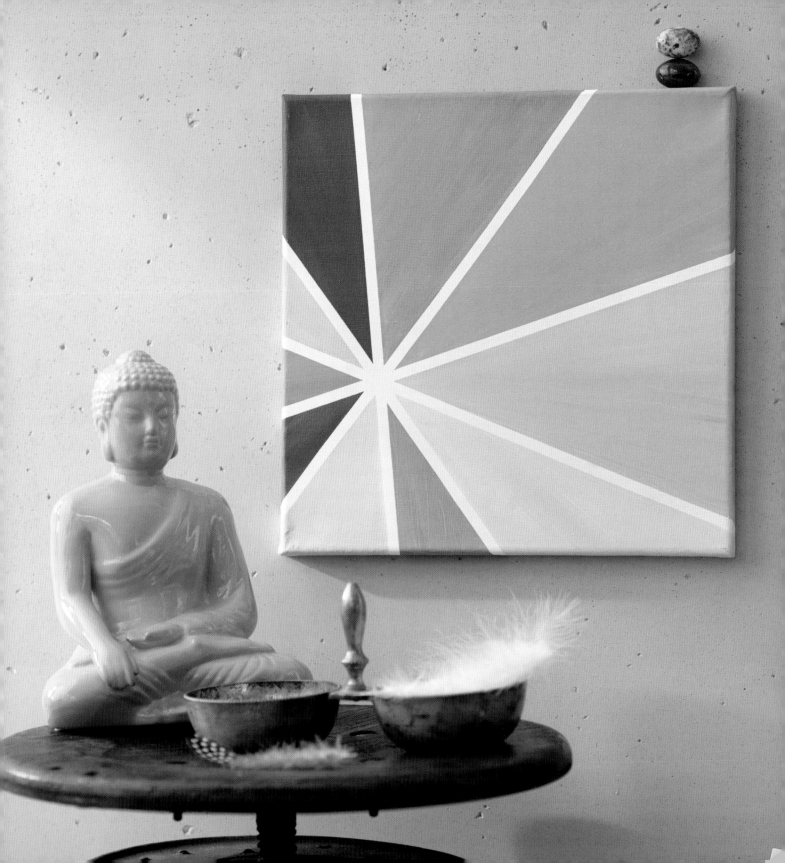

A World of Surprises

With time I have learned to accept what pleases me—trusting that the world has more canvases than I could ever paint. Trust yourself to simply go along with the way your painting dictates. Let yourself be led without a plan.

Materials

1 blank stretched canvas, square

Acrylic paints in titanium white, orange, magenta, yellow, green, and blue

Flat brush with synthetic bristles, medium

Black fine-line marker (or dry marker or waterproof black pencil)

▲ Lay down blocks of color in yellow, magenta, and pink, mixed from magenta and titanium white. Using the tip of the brush handle, create patterns of lines and squiggles in some spots while the paint is still damp.

◀ Create light shades of green and blue by mixing in titanium white and blocking each mix into areas on the canvas not already covered. Use the tip of the brush handle to write some words in script and a few more patterns before the paint dries.

▶ Add more white to each existing paint mixture to make even lighter shades than those already applied. Using a dry brush, paint inside each block of color with its lighter variation, leaving darker borders in some areas. Continue to add as much color as you like until you are pleased with the final result. Allow the canvas to dry completely.

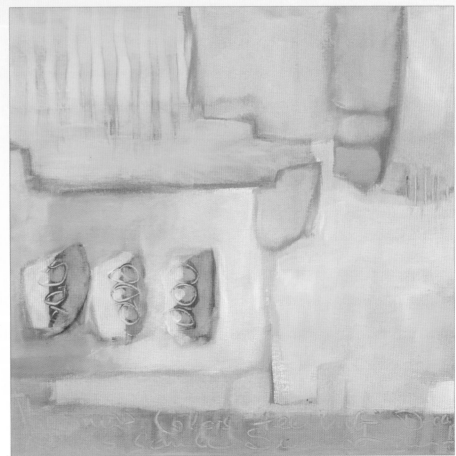

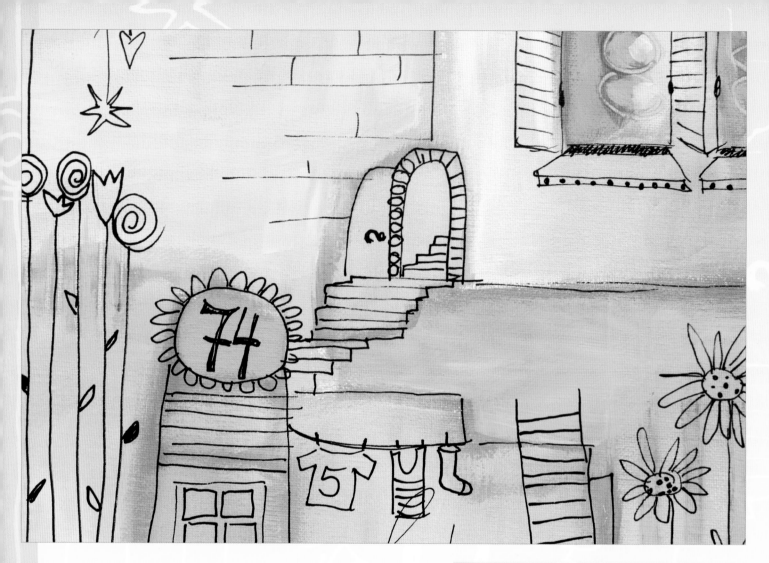

▲ I look at my painting and decide it is perfect for an abstract house, complete with doors and windows. With a fine-line marker, I begin drawing and doodling over the color blocks with the forms that I see in my mind's eye, getting as creative and fun as I allow myself to imagine.

If you prefer, use light pencil strokes to apply your scene; then trace over them in marker. Use the template on page 95 to recreate this scene on your painting or make your own!

These color combinations are bright and fun, lending themselves well to blending strokes into each other.

▲ When I take a step back and look at the picture one more time, I realize that some areas are still empty. I doodle in flowerpots, flower petals, and more squiggles and scribbles; then I paint inside some of the forms with a bit of white for contrast. It is the perfect finishing detail!

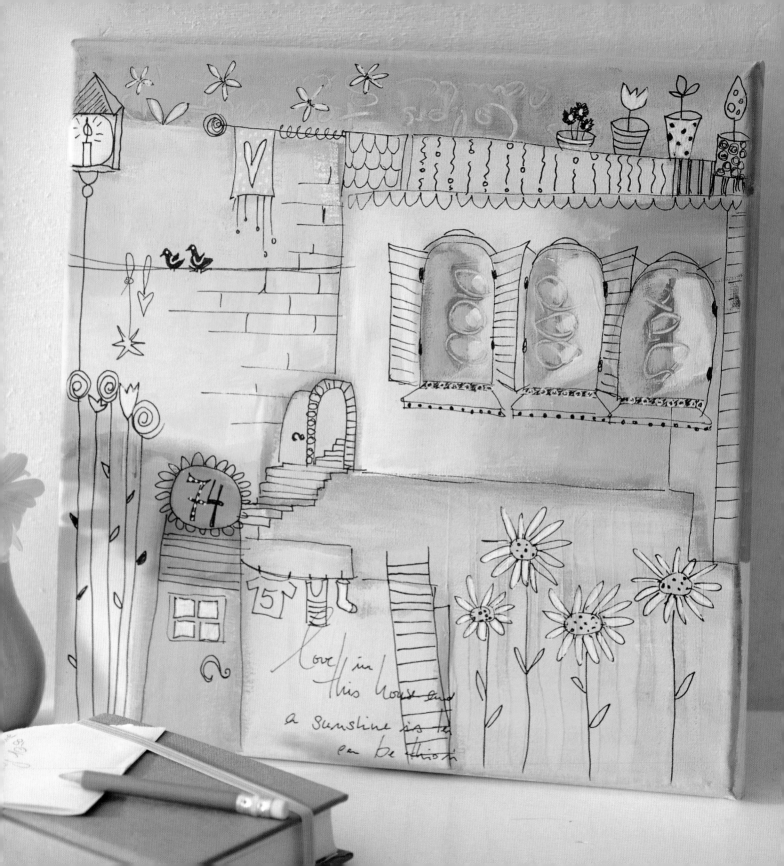

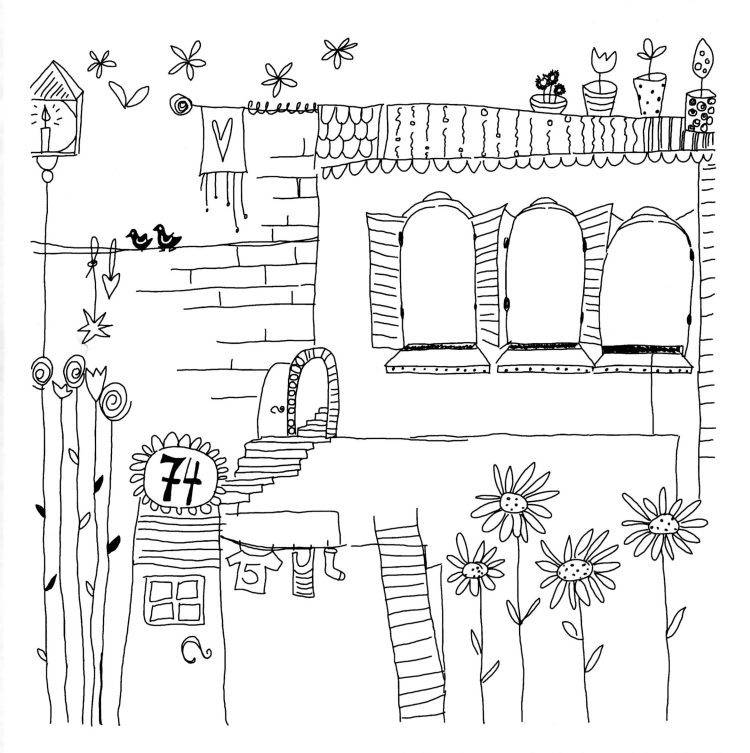

▲ Use this pattern as a guide for your own "World of Surprises" painting—or feel free to photocopy it and simply color it in, right here, right now!

About the Author

Isabelle Zacher-Finet has lived and worked as a freelance artist and lecturer in Berlin, Germany, since 2002. A married mother of three, her works have been in many exhibitions and shows throughout Germany and around the world. Isabelle has also gained national and international recognition through her seminars, workshops, publications, and YouTube channel. In her Berlin studio and gallery, she specializes in painting large-format abstract works, floral themes, and portraits of women.

Isabelle searches endlessly for new ideas to put into her creative work, whether a new form of expression, material, theme, or in finding new contacts for collaborative projects. She attributes her success to her versatility, which is also her approach to life. Isabelle believes that painting can be a bridge that connects people and engages others in conversation, and that it can bring joy to people, adding new substance to their lives. It is for these reasons that Isabelle gladly shares her knowledge and passion for art in various ways. For more information, visit www.zacher-finet.de.